The Golden Chain

Also by Anthony Rossiter

THE PENDULUM

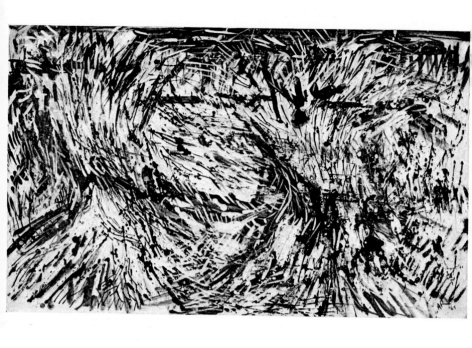

CONFLAGRATION OF CORNSTOOKS

Anthony Rossiter

THE GOLDEN CHAIN

HUTCHINSON OF LONDON

HUTCHINSON & CO (*Publishers*) LTD
178-202 Great Portland Street, London W1

London Melbourne Sydney
Auckland Bombay Toronto
Johannesburg New York

First published 1970

© Anthony Rossiter 1970

*This book has been set in Baskerville, printed in Great Britain
on Antique Wove paper by
The Camelot Press Ltd, London and Southampton*

ISBN 0 09 101770 X

For Father Aelred Watkin, o.s.b.
and Iain Hamilton
with affection and thanks

Illustrations

vii

Preface

by Professor Frank Kermode

Anthony Rossiter reminds one of the venerable distinction between sanctity and heroic virtue; he broods on the first but aspires to the second. Yet his heroism is both peculiar to himself and modern. His senses present to him a world which, however it may seem to be a brutal mass, may by the action of his imagination be caught up into significance, translated, as he would say in an idiom borrowed from David Jones, to the language of signs. And so, continually exposed to the world's terror and its meanings, he has in his life unusual dread as well as uncommon gaiety. It is devoted to the exploration of meaning by the grace attendant on the fidelities of brush or pen.

There is little resemblance between Rossiter's writing and that of the calculating literary professional. Like the player who could not keep counsel, he will tell all, the triviality and the unique moment of terror and insight (his car slewed across a halt-sign, he contemplates the painted word). If he does not shape or edit a remembered

ix

conversation it is because he has trained himself to record, raw, the 'signs brutally built by the discharged stones' of an old wall that looks as if it has been dropped like a bomb. A gate multiplies its meanings of life and death; in a landscape where madness and meaning merge, the significances are registered with rapt economy: 'the corn still wet shone small eyes of splendour'.

All these meanings arrange themselves in relation to the sentience and pain of one observer, the Pole and the Whole, the absorbed and splendidly selfish creator. He studies other artists, but he practises 'only Rossiter'. He would hardly agree with me that his conversation with Robert Frost is altogether less interesting than the celebration of his lyrical lust for nurses, his brief meditation on a schoolhat (a sign of the beloved child) or a row of bad puns presented to a psychiatrist. To him they are all aspects of a mysterious reality held precariously together by his life.

Rossiter is a teacher and a painter. This book is, in a sense, about these two vocations, both of which require the interpretation of signs. A heap of socks is a sign, as well as an icy furrow or a collapsing gate; white crockery against a darkening window in autumn, the seams of a nurse's stockings speak also of some enormous truth. It is no small thing that a man who has suffered so much—in ways he described in his first book *The Pendulum*—should remain continually open to the pressures of the world of feeling, and to the terrific meanings of objects rightly seen and so redeemed from a random reality. He adds, in his own fashion, a dimension of fear to the radiant visionary landscape of the English tradition—a tradition, so Yeats thought, that stems from Blake's woodcuts to Thornton's *Virgil*, and from Samuel Palmer who is one of Rossiter's heroes. Thence, and from wilder origins, comes the corn to shine small eyes of splendour. Thence also, in

a world which is sometimes obscene—like furtive life in the stones of some broken wall—comes the imperative: Rejoice! A special patience enables him to bear what he has to bear if the meanings are to be shown, the signs interpreted; and it also enables a humanly flawed voice to celebrate what is very close to 'a constant sacrament of praise'.

F. K.

When the sun rises.
Error is created. Truth is eternal. Error, or Creation, will be burned up, and then, and not till then, Truth or Eternity will appear. It is burnt up the moment men cease to behold it. I assert for myself that I do not behold the outward Creation and that to me it is hindrance and not action; it is as the dirt upon my feet, no part of me. 'What,' it will be question'd, 'when the sun rises, do you not see a round disc of fire somewhat like a guinea?' O no, no, I see an innumerable company of the Heavenly Host crying, 'Holy, Holy, Holy is the Lord God Almighty.' I question not my corporeal or vegetative eye any more than I would question a window concerning a sight. I look thro' it and not with it.

William Blake

The happy eachness of all things.

W. H. Auden (from *Prologue at Sixty*)

Introduction

When a friend suggested that the true sequel to my autobiography *The Pendulum* would be a book in which I made substantial and intentional use of my art linked to detailed descriptions of what I was thinking and feeling at the time I was working, I knew I could not resist such a challenge. For my whole existence is guided by my visual awareness and for quarter of a century I have practised and taught painting.

I felt that this exploration might be of use and interest in many quarters, none more important than the art rooms of mental hospitals. For in these rooms work of extraordinary vision, quality and value are created—often only discernible to perceptive people.

The aim of this book is to open up the windows of perception to a much wider audience. The following story will confirm the need for this.

While I was recovering from the severe pendulum attack described in my first book, in the summer of 1959, in a Somerset hospital whose art department was first-

rate, I was painting just outside the ward looking towards an interesting group of trees; one of the senior Consultants stopped behind my easel and stood there for about five minutes. He said nothing but I could sense his bemused curiosity as he watched me work. Then, quite quietly, in a deadpan voice, he said:

'You've made the trees look like a ship.'

'Yes—I know,' I said, 'they are *just* like a Viking ship— aren't they?' For that was exactly the image they formed.

My enthusiasm seemed to dampen his dourness even further.

'I suppose some people might think so.'

Then this specialist shuffled off without saying another word. I was filled with horror and sorrow; sad that the poetry of objects meant nothing to this consultant doctor; horror that such blindness could exist in an intelligent person in whose hands were the tormented souls of countless patients.

The seeds of *The Golden Chain* were first sown during those few minutes; their first flowering was in the form of *The Pendulum*.

I now offer this second season, hoping the blooms will bring new perspectives and views even to those readers whose windows have long been open to perception.

I very much want to thank Ronald Lewin for all kinds of objections and suggestions at all stages of the writing of this book. My thanks also go to William Manthorp for his photographs of the originals on which the illustrations are based and to Mrs Nicolette Webb without whom the typescript would never have emerged.

A. R., Ford, Litton

Preamble

When a subject is an object and an object can be a subject.

When an intelligent and highly emotional person selects a subject as the object of his attention he will have some clear idea in his mind why such a choice was made. At first sight a golden cornfield will perhaps reflect his joys and aspirations, a desolate wintry scene the darker side of his nature. He is drawn to the subject by an immediate recognition of something within himself.

But this can be surprisingly misleading as far as the finished work is concerned. After the surface 'temptation' has drawn him to work from it, and while the object is becoming the subject of the work, he will be discovering more and more about himself through the objects. Purposely I have now put the noun into the plural—objects—because any composition is built from a mass of details which have to be related to make the whole. And during the relating of these, during the intense search of the smaller units which will make the larger concept—the whole—many matters will be discovered and understood

which had not occurred, consciously, to the artist when he first set to work.

An artist reads his subject rather in the way that a fortune teller reads the palm of a hand.

In my own work I am always drawn to a subject because of the direct link between the 'mood' of the objects and my own at that particular time. But I am fully aware which is the cart and which is the horse. I choose a particular subject or group of objects because at that moment they reflect some part of me which I wish to express. They 'catch my eye'. But I am fully aware, after twenty years of living with my pendulum-like emotions, that the subject of my attention does not change; that I am the horse and the object the cart.

A maker of pictures or words is constantly being reminded of a million and one matters which he can use for his expression. And even when the maker is mature and able to select carefully what he does or does not want to use, on a particular day, he will involve himself with much more than he reckoned. That is the magic of art. And in the magic will be discovered some part of the maker which he himself probably never perceived at the time—or even knew existed within himself.

That is how a really positive maker grows up. Each day, through his 'handwriting', he learns more and more about himself.

Beyond this I cannot make any broad statement because, to put it simply, a 'bright day' (within myself) will not necessarily determine me to paint a 'bright subject'. If I am feeling particularly bright and perceptive, I may well choose to draw an aged rather tragic old man—to explore 'darkness' through my illumination.

And on a 'dark day' I may well choose, almost therapeutically, to search the values in a bright scene—to crawl out of my anguish and darkness via their opposites.

6

But however objective a painter is in his choice of subject, he will of course betray his mood in some way or other. It is just this betrayal, reflection—of which I am in pursuit through my own work and images. This is a very complex matter to understand. Perhaps another analogy may help to explain it better. A writer using a pen betrays probably more of himself in the actual 'scrawling' —his 'shorthand'—than in the words he is linking together. The study of handwriting is well known in the psychological field. Because the subtle link between sign and symbol is of such importance and so difficult to define, I shall turn to that great writer and painter, David Jones, for help in this matter. He has made a profound exploration of these matters, of sign and symbol, in an essay called 'Art and Sacrament'. This most perceptive, poetic and scholarly writer/thinker has stated that the art of man is essentially a sign-making or 'sacramental' activity. The essay ends with a quotation from Maurice de la Taille who explained what was done on Maundy Thursday by Good Friday's Victim: 'He placed Himself in the order of signs.' If I have read David Jones's essay correctly, he is affirming the doctrine of signs as anathemata—'the curses of each step' as it were—which taken in order make for the whole symbol of truth. Or put another way (and I hope I am not mis-representing Jones's important and complex theme by this analogy)— I would say that each stage of Our Lord's journey towards the Cross, as at each Station, were the signs; and that the Crucifixion itself was the symbol. For those who have no inclination to link signs and symbols to the Christian Faith in particular (and I am attempting to explain this matter outside my own particular Faith), I would use a non-Christian carpenter's tools for my task. A Chinese carpenter, for instance, intent upon his work of constructing a perfect wooden puzzle, will be using nails and glue

7

to hold it together, thereby making it a more perfect puzzle. The nails and glue 'give security' to what will finally be a symbol of much bewilderment to so many.

This book is an attempted analysis and description of the creative process illustrated by the end products. It is a book involved with seeing, feeling, thinking—and doing. It is a book dealing with the conjunction of opposites. I have only changed names in Part Two, the hospital sequence, to avoid embarrassment to those concerned. In 1964 I spent a long time, summer and autumn, in a mental hospital; for the sake of the form of this middle sequence, I have linked another Christmas spent in a hospital to these particular months. Looking back over five years, those separate days and weeks and months appear as very much part of the same chain, though often far from golden.

Part one

For what are men better than sheep or goats
That nourish a blind life within the brain,
If, knowing God, they lift not hands of prayer
Both for themselves and those who call them friend?
For so the whole round earth is every way
Bound by gold chains about the feet of God.

Tennyson

Chapter one

One late afternoon in the winter of 1964 I passed a small copse of trees which in the past had been guarded by a finely proportioned gate.

Some lines from *Cymbeline* shot into mind.

> Fear no more the heat o' the sun,
> Nor the furious winters rages;
> Thou thy worldly task has done
> art gone and ta'en thy wages;
> Golden lads and girls all must,
> As chimney-sweepers, come to dust.
>
> Fear no more the frown o' the great,
> Thou art past the tyrant's stroke.
> Care no more to clothe and eat;
> To thee the reed is as the oak:
> The sceptre, learning, physic must
> All follow this, and come to dust.

This gate had spoken immediately to me of death; no false expression, powder or pretence allowed it to varnish its face. It leant more than a little to my left, and sought to its right a long last look at a post which had long indeed ceased to be. As I drew (first raptured by its swift slanting movement) my mood soon took on the meaning of its stance. Quickly it became for me a figure starved to death, skeletoned in life, clinging to an aged father—searching for its long dead mother. A thin emaciated youth crying out for the trinity which with his parents he once made. The desolation of that gate entered into my soul as had the corpses of the concentration camps of Europe some twenty years before. It was a silent, hopeless cry like theirs. Was it, I asked myself, because of its silence that it cried in vain?

On its central post was nailed a fragmented piece of wood similar in every way to the one which two thousand years before had had INRI inscribed across it. Oh God, I thought, two thousand years ago, twenty—and now!—oh God not again. Not again oh God. Please Lord not *again*. I looked to the trees beyond and began to draw. I drew that agony as it was, and always would be, until finally that skeleton was released from view and buried beneath the briars and trees—its memorial—one post, curly topped with ivy, faintly shiny. I thought I should never entirely banish the picture of that bare winter gate from my memory. Would I easily travel the diagonal of a wooden gate without being driven down and down? My answer came quite simply five months later—like a little miracle, while I was drawing the summer gate at the end of what had been in winter a muddy, sparkling lane. The firmness of the horizontal bars shot their confidence from left to right. So straight and sure, still and solid were they all that the message of that diagonal bar became the most important part of a Pythagorean dream suspended from a

timeless bar on top. The scene around it took on the per-
fection of a 'golden day', one bush to another bush on
wing took flight up the trunks of two solid trees and met in
forking branches poised above the bayonet verticals of
growing summer grasses. In my exhilaration I stepped
through that grass—right into a hidden puddle. Water is
just as wet in summer as in winter, but thank Zeus, it's
warmer.

Two Christmasses ago, shortly after I had learnt that my
autobiography was to be published in England—I awoke
to a landscape veiled under a thin covering of snow, as
far as the eye could see. I hurriedly dressed, dashed down
the stairs and collected my drawing things—only just
remembering to top my clothes with a thick woollen
jersey. The ploughed field at the back of the house dic-
tated my subject matter immediately. A vast sheet of
frozen waves lay spread at my feet stretching away to an
horizon which was as clean and sharp as a knife.

Although the scene was the essence of calmness—upon
the surface—the pendulum of my imagination was swept
into fuller flight than I had known for a long time. As I
began to draw, a torrent of images and associations
streamed through my mind. I became not only part of
the frozen sea stretching before me—but intimately in-
volved with its past and the actions which had fashioned it
to the present panorama of ruckles and ridges. As I drew,
I crawled up and down these slopes, over hills, up moun-
tains—down deep trenches—over chasms into cavernous
shelters—and all the time messages, words, phrases and
ideas cumulated in my mind—spinning round—shoving
and dissolving into each other to make room for the next.
The stillness of the morning and the frozen shapes had,
for a moment, spoken to me of finality—death; but the

dazzling freshness of that scene and the sparkling air fiercely contradicted this—so that an exuberance of life splintered within me like water spitting out from the holes of an unfrozen pipe which has burst. That small part of my mind which did insist on final negation, was precluded by the rest which insisted on life. The more I drew, the more resonant this life/hope message swelled within me—dramatically, incisively alive—bursting for recognition.

The still drama of the frozen furrows reminded me of the contrast between the outward calm of an operating theatre and the urgent, precise activity which takes place within it. The field became in my imagination a magnified figure lying on an operating table into which my pens and pencils probed. The more I drew, the clearer these hospital associations grew—knives, bowls, beds, tweezers, limbs, legs, pulleys, trolleys, aprons. . . .

Suddenly a line sang through my head.

Oh the apron sight of such a morning!

I drew on, words and rhythms, phrases and sentences marshalling themselves together without my aid. CALM, FLOWERS, BOUQUETS, RIBBONS, STITCHES, SPINNING, PAIN, POPPIES, BLOOD, NEW LIVES – WORN OUT PATIENTS – HOPES . . .

And as I continued probing into that frozen field, a poem was born—my experiences in hospital weighed against mother nature. It was later to become the poem called *Frost, Boxing Day*—the first I ever published.

Often when I am drawing, I make quick visual notes for future use in the writing section of my craft—with of course no thought of exhibition or display afterwards. They are my 'shorthand', reminders of the visual impact of the scene and its associations for me. Then I make poetry or prose by writing down a word or phrase—*in situ*—'drawing it out' in the quiet of my studio soon

13

afterwards. By this I mean literally drawing or designing it on paper, unconsciously allowing the doodling to take care of itself and rendering other images closely connected with the first. I do this specifically to track down some particular visual image or impact which lies half slumbering beneath the obvious meaning of a word or phrase. I give the exact visual notes made in the studio after drawing those frozen furrows and from which the final, ordered version grew. (These notes relate to the first half of the poem; the remainder are lost.)

Frost, Boxing Day

A lawn leading to a ploughed field—with woods behind:
 The apron sight of such a morning
 calm collected in its wrinkled furrows
 turmoil past sewn with passions seeds
 in lines of trenchant war—cornhigh hopes—
no poppies now like hand grenades are blasting—
the past rippling waves mown down for winter's starch
 —past furrows
 wrinkled smooth from the heat of iron;
 worn out patients, duty late with pain, caring,
 bending
 re-making restless beds—
 the shadows tendered by the tone of white—rustle of a
 bridesmaid's veil,
 SOME BOUQUET THIS MORN—to a bride, no virgin love,
 when such a passion collected is from the frozen past—
 f l o w e r i n g
held humbly feet to headbreast high, robin, ribbon red;
 none like the present of a sky—no limit—to the hopes of
 future
 cerulean china, all of a piece. . . .

Nothing is fashioned hard that cannot in a trice be
 smashed—
this side of eternity. . . .
 a fossil, few and far . . . between. Rash
 to attempt the impossible holding to the bosom, no waste
 this present
peace, no future cares . . . some hope of keeping!
 Rash to attempt the impossible?
 It's worth a try—a tonic, the doctor said, a rash the
 symbol
 of a cause—
 A symptom for the future use—
a race to run. started now—
 NO. Much further back than those faint woods of grace,
bared from summer's sumptuous splendour—to the
 skeleton of all.

I shall be discussing how another of my poems came
into being later in the book; meantime having spent some
time in the furrows of that frozen field with its implicit
message of waiting expectancy and controlled drama—
and which awoke in me more tumultuous songs—I want
to take you to the other extreme of the pendulum when
all the frenzied forces within me were roused by an old
broken down wall enmeshed in weeds and tangled
growths. I remember this drawing with icy clarity.

Chapter two

I had driven to Bath to buy some paints soon after breakfast one winter's morning; during most of the return journey my thoughts had been filled by the differing notices located by the roadside. One of them had proclaimed 'DANGER AHEAD'. Such a warning seemed almost an anti-climax when one discovered what did lie ahead; for to drive past a neatly dug trench at the side of the road and a group of shirtsleeved workmen is somewhat disappointing. Such a notice tells either of a dragon belching fire, a bridge under total collapse—or more mildly—the tail of a bomb to be seen protruding from the centre of the road. One notice *had* seemed nearer its intention—tilted by time to point to the skies. 'CAREFUL COWS'—it proclaimed towards a bright white cloud.

The whole matter of signs, and appropriate symbols filled my thoughts on that drive back from Bath. As a painter I recognized that the signs which went to make symbols were often almost inseparable. The brushstrokes

which built up the whole 'sign' were an integral part of the message. And such contrivance in road signs would, usually, be inappropriate—if used in combination with letters and words. For there is something faintly silly about a notice which proclaims 'FIRE' with the letters zig-zagged to engender 'real flames'. The purposeful (and partly facetious) part of one, demands in such an incendiary message—if it be true—that the letters themselves be devoured by the flames.

All this occupied my thoughts as I wandered down the lane, near our house, in search of a subject matter that particular winter morning. Climbing the hill I was sent over and down the other side by the bar of a gate which pointed its sinister finger down and down. So that I was not much surprised by the sight I saw across the field at the bottom of the hill. A long stone wall lay twisted in the last throes of the death agony. Its serpent shape hypnotized me as a mouse is paralysed by the sight of a silently slithering snake. As I approached, my thoughts turned back to those 'inaccurate' road signs—for here both in the sign language of the crumpled wall and the growth which sewed it together—and the total expression of its agony—was the complete marriage of sign and symbol. The signs so brutally built by the discharged stones were a message whose irony was heightened by the determined stitches of the undergrowth; the symbol was fully expressed in the gesture of the whole composition. Death spoke to me fiercely as I drew and struggled with that wall; not just through its total collapse, but through the venom of the undergrowth and weeds, their vindictive insistence that death should be *seen* as well as told. My own flowing rhythms were constantly halted and re-directed, zig-zagged here and there, in and out, back, down—round—up and zig-zag down again; the act of drawing became like a protracted period of toothache; the very wall

reminded me of rotting teeth; I felt every inch and 'tooth' of their agony. I could not get over the insistence on death—or rather the death wish—'to be seen and felt as well as told'; it occurred to me then that we very rarely (except in war or working in a hospital) actually see death face to face; we know it secondhand. I emphasized, time and again, during that drawing, the weight and power of falling stones. It was as if the wall had been dropped from an aeroplane a thousand feet up like a bomb; and that a radiation had been set up by this act of demolition spreading into the cancerous growths around it a special brand of poison upon which they thrived. I marvelled on the way nature, whatever the circumstances, finds her own most perfect patterns with no thought of display. The wall spread itself with a certain languid ease exhibiting perfectly its complete state of disintegration. It was a performance of which most actors would have been distinctly jealous. The precarious, yet steady, stance of stones seemed to bear witness to a capacity and sagacity in keeping with conscious will power. Through the growth of the weeds and hedgerow branches, I was again and again reminded of nature's design whose only dictate is that of survival; reminded too, through the merciless patterns and strongholds, that survival demands cruelty and obedience, the incredible insistence of growing (almost snarling) nature heightened the irony of the pathetic wall which possessed the death wish of man to an almost indulgent degree—and yet still clung to a thin and precarious hope of survival. Often the memory of those atrocious sights witnessed in the concentration camps of Nazi-occupied Europe came to mind. As I drew, this wall became the remains of tortured victims of such a state of hell on earth and I thought of the branches, perhaps a pair of them, slowly growing and moving—centimetre by centimetre—gently dislodging the bones fractionally this

18

way or that—like a vast game of spillikins invented in hell and played out on earth.

I called that drawing by several names—the most appropriate, I think, being 'Snakedeath Wall', and I think some of the right signs were employed in the making of that symbol of destruction.

Another wall, a lonely one near our house, which usually declares a certain complacency in its disintegrating self—made quite certain in my mind that it too was heading for the kingdom of doomed destruction. It declared this, and nothing else except its desolation—as I approached it that late afternoon. A wind was blowing the late afternoon into an early October evening whose ruinous dark was already heralded by the sky. The charred remains of the day, in the sky, were the dark testament of a savage winter's night, the land around already anticipating this sombre solution in its tonal sympathy. It was a conspiracy between earth and sky which watched, as well as heralded, an approaching crisis—just as a witch, occasionally looking up, stirs her pot of deathly brew. I felt myself to be a miniature reflection of the whole landscape and approaching drama, just as the flickering hairs on my wrist echoed that blowy, frightening scene—and yet were no part of it.

Gates have fascinated me for a long time. When first I became seriously involved with the exploration of landscape through my painting—I used them entirely 'unconsciously'. I think at a rough estimate three-quarters of my landscapes have contained, somewhere, a gate or similar posts and wires. I am now fully aware of their symbolic

content which will be explored, for several reasons, later in this book.

A few miles from our house I passed, each morning, a gate whose barrier defence had been somewhat smashed by more than just the daily struggles of life. The impact of a tractor or lorry had left itself distinctly—and most decoratively—upon that gate. And each time I raced past it—a small flicker of hope ignited inside me—for I recognized, woven within it, two important matters related to myself. First, a distinct sensation of being more than a little bruised and battered by life—forty-oneish plus—and secondly (perhaps not so easily recognizable to those who do not inhabit this island), the pattern of our most distinctive national flag—the Union Jack. Every time that I drove past this extraordinarily fascinating semblance of part restriction in my bright red car, it pushed the pendulum a fraction more. It began to stir certain jingoistic tendencies within me—putting in mind our proud national emblem married to a sort of John-Bull-ruggedness-of-determination—which, I am told, represents more distinctly than any other characteristic the people who live in the countryside which I love so dearly. Just for a second or two—each morning and evening—the clash of cymbals quickly followed *Land of Hope and Glory* within my emotive system—linked, of course, to Blake's immortal *Jerusalem*. I make absolutely no apologies to music lovers who do not share my jingoistic reverence for these pieces of music—particularly as this John Bullonian battered gate stirred my soul to life again—at a time when I truly believed that the dark insistent hairs on my arms and legs would never tingle again, as I was enduring a deep depression.

As I drew that gate I was constantly reminded that Robert Frost had, once and for all, hit the nail on the head concerning barriers when he wrote that line; 'Some-

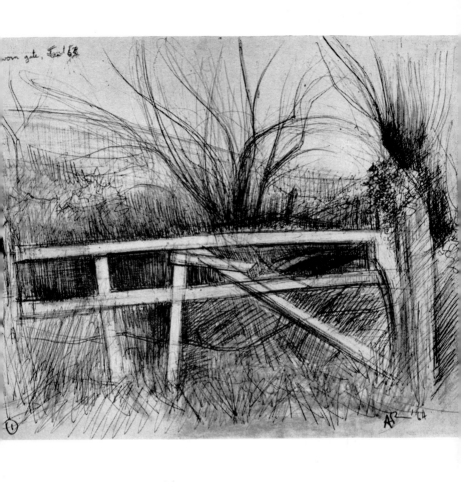

WORN WINTER GATE (see p. 11)

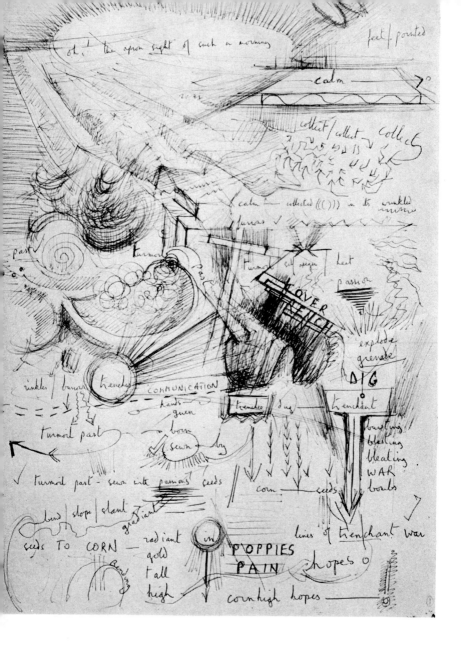

Visual and verbal doodles for FROST, BOXING DAY (see p. 14)

thing there is that doesn't love a wall.' That went for all gates too. That noble, 'permissive' fence/gate—call it what you will—eventually for me became *The Land of Hope and Glory Gate*. But it did not happen overnight. My emotive system was in dire need of fresh oil.

Chapter three

October

The trees which in summer had painted the heavens to a perfect tone of Wedgwood blue—now in autumn encouraged their charcoal fingers to start winter inscriptions upon the skies. How best can I describe the miracle which played itself across this backcloth?

I must begin with a sky which allowed the sun to break through one rainy evening and arch a rainbow from one end of the West to the opposing East; the radiance of that link, that evening, only accentuated the fears jostling within me—and I sensed a giant multi-coloured padlock anchoring me even more firmly to the ground—ordering me down and down into the bowels of the deep, wet earth. The sun had commanded a rainbow to shackle me catacombed within a Roman dungeon—tormented by a myriad array of colours as fugitive as phantom oases flickering in the mind of a desert traveller denied the quenching of his thirst. I drove towards this Roman jailer, my teeth as firmly clenched as any arena slave of

yesteryear—searching the phantasmagoria of this mocking mirage as ardently as any explorer lost in the desert sands. I should have looked less at this scotomatized sign of seeming splendour and more to the road beneath me. For do not forget—as I had done—that I was in search of oil not water. Almost too late I was drawn to a knife stop halt by a sign whose lettering lay white upon the road. I flattened, fractionally, even more in the dangerous skid the stratum of that silent screaming sign—crying HALT! The exclamation mark, missing from the message laid upon the road, fired fast its ball directly to my heart.

It was then that the miracle occurred.

The rain, fiercely vexed, drummed down upon the road—and the road, no less cross, returned the fire in all directions. My car was poised diagonalled on the T of HALT whose perspective had so sharply shrieked me to an urgent stop. The raindrops aimed their insistent barrage at this letter of the law which nimbly deflected the minute bombs, exploding so ecstatically, to left and right. To right and left they sparked cancelling the barrier of the crossbar—extending the lateral message of the letter—left and right, right and left, out and up. 'Don't stop here', the T bar cried, 'carry on to left or right. . . .' With caution I took counsel of their words, let in my clutch and turned quietly to the right. 'You are free,' the wet road seemed to say, 'free to feel and sing aloud again.' And at the same moment the sun broke through commanding a superlative rainbow. That rainbow, on that glory glaze of evening—as I approached it with calm and care—alighted on two green fields, high upon two hummocked hills, whose azure glow wrought both ends to golden green. From the depths of more than earth and rocks were raised two anchors by their chains whose points of fishes' tails danced, delighted upside down—or rather up and up—telling tales through glistening,

gleaming grass—of light and gold and green as soft as any gauze of gossamer whose glow diaphonates the true hyalescence of all our being. 'Up and out, out and up—out and out—up and up!' the rainbow anchor sang.

I drove contented home, the memory of that road sign splayed out and out—linked to the upsurge curve of those dancing dots on those azure green to golden hills. Once home I went quietly to my studio and re-read Wystan Auden's recent letter. It had always, even in the darkest moments of my long depression in the summer, made the fullest sense to me; but on that evening it spoke again—through God. I quote just the last few lines of the letter.

> The best 'psychological' advice I know is what the White Queen (?) says to Alice.
> Say the French for a thing when you can't think of the English, turn your toes out as you walk, and remember where you are.
> With best wishes for a brightening day.
> Yours,
> Wystan

Quickly I pushed back the chair from my desk, stood up and turned out my toes to match the road halt sign—making a rainbow arch as I joggled round the floor of my large studio in delighted celebration.

I no longer felt isolated and alone; I became again healthily aware of my own duality and my relationship to the world as a whole. I began to think much about 'paired duality'—or opposing duality, thoughts stemming from the classic example of birth and death—to ones nearer at hand.

I think the first time that this matter of duality really

struck me forcibly was whilst recuperating from a leg operation in St. Thomas' Hospital and about which I wrote in *The Pendulum*. For those who have not read this—I quote the particular passage because it sets the stage for the next few pages of this book—which concerns itself entirely with CONTRA-RELATIONSHIPS, duality and contradiction, marriage and friction. . . . Furthermore this image asserts for me the most important point of all—the *necessity* for contradiction and our daily attempts to recognize, understand and tame this fierce element essential to life and survival.

Recently, during a time in hospital for further leg operations, I understood more clearly the duality of our natures, through a simple visual image, which expressed to me the strife within us between good and evil, our Jekyll and Hyde personalities, the link between anima and animus, our paradoxical make-up and our daily conflicts, when I watched a nurse using a pair of scales in the ward. I was a little drugged, lost a little to the world and its full realities, and lying relaxed upon my back. A nurse was having difficulty in measuring two quantities against each other on a scales. The left dish insisted upon outweighing the other, and I saw in it the bully in life, the one with the 'whip hand'; the right dish, uncomfortably aloft, seemed to stand small chance, as does the 'little man' in life, of exerting its influence. Then, quite suddenly, a small miracle occurred. The nurse equated the scales more nearly to a perfect balance, there was a tremor of delight as the two opposing dishes made a final frictional effort to disagree, and then there was perfection as the dual forces married in harmony. Even in my drowsy state, my heart stirred with joy at this revelation and perfection. And in the final tremors, before there was final

marriage, I sensed the last moments of the love act, when animal fury and passion have abated and there is a stillness, a 'lostness to oneself', a union, which is entirely free of the ego. I thought that perhaps this greatest creative act of all possessed, in its way, the eternal instinct of man—the death wish; I thought, perhaps that is God's answer to our duality of nature, in whose action is found the safest way of 'dying to oneself', creatively and positively.

I have said that the first time I recognized this matter of duality—consciously (and in an adult way perhaps)—was through the miracle of those ward scales. But being a twin by birth, I have always been intimately involved with the delights *and* dangers of duality. I think the second time that the fierceness of duality—in visual terms—really struck me was when I was painting two cornstooks ravaged by a night of storm a year or so ago. I was, of course, 'drawn' to them by the very qualities which are so much part of my complex inner/outer nature. A fierce system of dualities which are in constant opposition—fanned, at times, to even greater flames by my boyhood experiences of twinship and struggles to discover my own identity.

Face to face with these wild manifestations of unruly nature, whose temporary taming by the harvesting farmer had been more than somewhat ruffled by the night's display of fury—a title/theme for my work shot like an arrow into mind. 'Conflagration of Cornstooks.' There before me were the fierce love/hate contradictions of ourselves for any perceptive eye to see. And whilst I worked, a line of poetry wove itself into my imagination—round the theme of twinship. It needed a little sorting out in the quiet of my studio afterwards—to become: 'Twins should be parted at the second of a birth—from the first—

before the tweezers of love close in on hate in the second death of parting.' The image of tweezers was born, in the first instance—visually—by the pointed arch which linked in love the two fiercely opposing stooks of corn. But as I worked—this triumphal Gothic Arch turned into a vast pair of pliers whose obsessive wrenching made audible the anguished screams of stooks; the giant forceps were, as in a doctor's hands aiding birth, both extracting the last link of one body from another—making two—and in their action making a oneness for themselves. The whole paradox of life and death spun singing in my mind—the need of two to make a one which in itself is not a whole without a contra-relationship/duality. The central fusing, fighting archway—the egg of life whose unity must needs be smashed for the birth of matching opposites made to mate their oppositions in a frictional fusion of creativity. The whole paradox of life was spiralling there before me: the twisting torment of our daily struggles sang from those conflagrating stooks of corn as clear as any flame of candle whose pyrotechnics echo, in glowing fire, the sculptured arches of our Gothic churches. The scintillation of this scene burned fierce within me—as I worked— struggling, striving, seeking to unite one form to another in a harmony of empyrosis.

'Is this not, at root, the basis of the sexual creative act?' the stooks continuously exclaimed to the foreboding sky—'is not the phlogiston of our fire the essence of all creative power? Is that not the pyre upon which our pains are laid for the matching of our mating opposites?'

I knew with each fresh streak and stroke, the hurt of tweezers teasing tight and sensed—each and every time— the blissful union of those converging closing claws into one finite, perfect, peaceful point.

Exactly echoed were the fractions of those ward scales which too had, in tremulous delight, married in a moment

27

of complete and silent harmony. The peaceful point—so sharp to feel—so perfect at the end.

The 'silence' of the cornstook conflagration—the momentary peace which passeth all understanding—came through the conflict of that corn and the conflict known within the drawing. Thus is born the only true reward of making. All else is false, a mere indulgence; unless the space, thus hollowed, is gently filled with a spiritual assurance of values far more important than streaks of paint or streams of words.

And so it was that day; and for the next I planned a piece—within my soul—which would somehow, in visual glory, make the one which is born from the conflagrating two. But this further drawing, state of mind, did not come as easily as I had prayed/expected for. The emptying of one's burdensome load of 'self', to allow the soul full space and stillness, is not easily achieved by any making person. The next few cornfield drawing days poured a cascade of shimmering charm/delight mingled through the heart and hand of fury upon my board, but did not—for me— achieve the unity so much desired in visual terms. Rain and storm confused the cornfields even more during the following days of work—and what was for the farmers a dismal sight, I must confess, was for me an almost pure delight. One corner of a field, in particular, tempted me to its rain drenched corn whose heads were mostly bowed in shame; somehow—and that is the way of nature —one portion of that field had resisted the heavy on- slaught from the skies—was not bowed down in false humility to the ground with no eyes to look around and laugh and sing; from the storm it had wrested a twisted flame of fire, a challenge to any eye, whose spiralled stance was more a rope than a tower of strength—for in wisdom, knowing well these winds, it had construed, correctly, that twists of sisal build together more in strength than

tiers of bricks. It knew, well, that all creation/life is spiral. And as I drew, my soul was purified by two bows in opposition firing/fusing themselves into the wholesome flame of corntwisted sisal stook of God's creation. I knew, then, through the struggling of my senses the freedom of arrows loosed from two opposing bows whose half circles construct, in fullest measure, the whole when faced inside to inside. And for the first time, I think, in my working life—I knew these bows face to face forming an x of ecstasy, but without the pain of yesteryears. 'Alone, yet married,' sang the spiral sisal stook. I remembered somewhere reading a letter by D. H. Lawrence—about not exceeding the soul's elasticity—going smash—like a tower that has swung too far. I knew during the making of that fiery drawing the wholeness which must not exclude, but rather embrace, the egos of us all. The corn still wet shone small eyes of splendour, a million of our atomic selves exploded without danger to the whole. Those eyes which now shone in splendour, had so recently wept crucified in shame; I knew again the necessity for pain, humiliation—crucifixion—but more important that our glory won through shame would rise up time and time again. The Resurrection, I thought, is more important than the Crucifixion and yet bound together for eternity. The Y of suffering needs extension down through the arms right into the thighs, for then—and only then—is the mandala of x made whole again. My mind was more upon the figure of Our Lord, at that holy time, upon the cross—making in his supplicated sacrifice and through his figure, the whole unison of more than shape. A shape which makes for praise—*that* I thought the most important matter of it all—a shape which makes, once and for all, for eternal praise. Once and for all. For all time. For eternity—the sundial caressed and shaped by an eternity of shadows. The perfect circle, the O as round as the one

in—and drawn by—Giotto. O the praise! Oh—add the H for height—the need for higher, fuller—more eternal, rounded, perfect praise!

Thus sang within my soul those arrows freed for a time from world desire—flamed and fanned through the corn-twisted sisal stook of God's creation. 'Through', I thought, not 'by'. Through those corntwisted, contracted strands of corn was born a message—*through*, not by. The Christ Child was given life *by* a marvellous mother—through Her He came to our world to die and rise, like that battered corn, again. But no corn, however sisalstooked in splendour, gives birth *by* its pain. It just gives corn—and grist to any mill—and hope by the mystic sign enclosed within the grain which in itself gives life by what it is Godgiven for.

In order to give the right perspective to this chapter which concerns unity, duality, and contra relationships, friction and fusing—and to stress the complexity of finding the 'perfect harmony', 'the golden chain' or 'peace which passeth all understanding' (particularly for a highly emotional artist), I shall in the next chapter use some extracts from the Painting Notebooks which I kept way back in 1960–1. I think that these entries, raw as they are—perhaps *because* of this quality, often written late at night after a hard day's work (and certainly with no thought of publication) will help to explain as clearly as I can how and why a painter works, with an *inner critical eye* which is more important to him than any pen, brush or canvas. Without this 'soul searching' in pursuit of unity and wholeness, both as an artist and as a man, much of one's progress (if it be such) could not have occurred. I shall, as it were, in the next chapter be presenting the 'bricks' which made possible some of my

future 'houses'. These raw materials, entries in my Note-books, may perhaps explain at any rate how one painter works. I have purposely copied them *exactly* as they were jotted down, with no thought of 'aesthetics' etc.—to con-firm my belief that no maker of 'res' is essentially con-cerned with 'aesthetics'. An artist is too busy 'making aesthetic judgements/decisions'—within and without him-self—to give much actual thought to this subject. The dictionary defines 'aesthetic' as; 'pertaining to apprecia-tion of beauty, *esp.* in art; keenly appreciating beauty'. 'Aestheticism' is described as 'exaggerated devotion to artistic beauty'; 'aesthetics' as 'study of beauty and ugli-ness; the philosophy of taste'.

I think these make my point for me, particularly the latter one—'aesthetics' as 'study of beauty and ugliness etc.' A maker of 'res' does not 'study' beauty and ugli-ness—he *uses* and *relates* them, willy nilly, left, right and centre throughout his working life. It is of course *not* beside the point that he is *concerned* with 'aesthetics'—in the sense that he is 'making them'—but it is the *house* that he is after through the use of bricks. His task is to place the bricks together in the manner most appropriate to the symbol which he is re-presenting. Or put another way, the privilege of an artist is to be able to see both the woods *and* the trees.

Chapter four

Since some of the jottings from these Notebooks concern a series of DESKSCAPES, how/why they came about etc.—I start this chapter by discussing one of the results, 'houses' which was built from them, before the quality of bricks are examined. Often, in my work, I have sought to link—somehow—the material world with the immaterial. For me, my desk (or anybody else's) is just as much a 'landscape' as the ditches and hills which surround the village in which I live. Moreover, it is a landscape dotted with personal poignancies, revealing the user *almost* as clearly as his face or gestures. We leave littered *everywhere* traces of our characters, habits, needs—neglects—essentials, for any perceptive eye to interpret. A desk—or worktable—during or after work will inevitably be stained with the owner's/user's personality, just as clearly as a room reflects the person who decorates, inhabits and loves it. Thoreau consciously declared himself just as 'self-consciously' as we more 'sophisticated dwellers' do—through his Walden home. He cut his life down to the

bare essentials, just as any maker of 'res' does in his work. His way of living was just as much an art, in the spiritual sense, as the book he wrote.

Although I cannot claim his ascetic approach in my way of living, I should like to point out—not critically, for I am a fervent admirer of Thoreau's work—that his asceticism was carried almost to a point of self-indulgence. But being a spiritual indulgence it harboured well his craft. Thus I should like to claim, in some small measure, the same *intent* in my way of living—which depends a great deal upon an easel, desk, papers, ink etc. My intent to unify daily life with my making activities, surrounded by the warmth and comfort of our farmhouse, was the intent of the deskscapes. My life, like most artists supporting families, depends upon certain essential material goods—and the 'cost' of them, both literally and metaphorically flood my desk each week. Rather than discard them—do a 'Thoreau' (tempting as it is at times), I resist this for several reasons, none more important than the education and bringing up of my two children. Thus faced with a pattern of life which needs 'facing', I attempt to use *any* facet of it which reflects our daily life set amidst the Mendip countryside.

We moved to this beautiful village of Litton, five miles from Wells, early in January 1960 with our daughter Annalisa, who was then nine months old. There was during that move and spring of 1960 a 'burstingness from everywhere'. Our new born child, our new found home— my new found teaching post after the illness of 1959 as recorded in *The Pendulum*—all these pearls set amidst the oysters of our happiness as reflected in the bursting blossoms/buds and bayonet grasses of our fresh mown lawn—all these demanded keen attention; and as each day passed my desk was strewn with some record of these vital struggles, delights cum difficulties. And thus was born

33

upon my desk some part of that ecstatic spring; flowing across the dark sienna wood were papers, flowers, envelopes and flowers; the desk took for itself by more than instinct—by its right—echoes of nature's spring outside, reluctant to be the passive spectator to the creative spirit of that season; not in jealousy—(a little perhaps in envy)—but in *pride*.

And so I painted it. With love, by passion's hand prompted by a grateful heart. The marriage of the world which we had grasped—that was my intent—as I drew, painted, smudged upon the white primed board, the confession of my loves and tribulations—which at that instant seemed as one. And *that* is the point of art. Art may be a tough task master but it possesses its own 'blessed poppies' which morphine the human spirit through its greatest trials.

'Spring Desk' nearly eight years on, once again I salute you—thank you—for the tributary of joy you afforded me so fruitfully. I worked hard *upon* you whilst you worked wonders deep *inside* me.

Oh 1960 Spring—you are now so very much a part of me, this dark winter evening of '67.

Some extracts from a notebook of jottings relating to my painting—and art in general, 1960.

February 1960
At the start of this year—I have commenced work on a 'Hedgerow' theme—mostly, as yet, in watercolour and gouache. This theme has been in mind for a year or so—and at last I feel ready to work on large paintings concerned with this aspect of nature. (Besides more ambitious Windowscapes and Gates.) Also Desks. 'Deskscapes' shall I call them?

34

What *is* it that I want to say in these works? First I know that the almost infinite rhythms draw me to the hedgerows—their swirling branches, the lyricism of the internal movements, the sweep of the whole—the intensity of their dark silhouettes against the open landscape. There is a fierceness in this branch life which I find in keeping with my spirit—and the most important aspect of all—a chance to get away, eventually, from Romantic Realism such as my work has been mostly concerned with up to date—particularly 1959 exhibition.

I hope to abstract much more—to use these hedgerows rather in the way Leonardo used flood scenes to express an 'eternity of Flow'. Inherent in these hedgerows are the 'growths of life'—gnarled, old, new, fresh, fine, sweeping, curving symbols of all that goes to make NATURE. As one works one is more and more conscious of the unending power of life,—the grit and guts of it all. Not for the hedgerows—the final years of stately, aristocratic grace of aged, oaks and beeches. The hedgerow symbolizes the incessant struggle of nature—in its skeleton form. Working beside these hedges, is like working with an X-ray lamp directed *on* to nature. It is this X-ray of vital growth that I wish to explore.

To jot down, almost at random, some of the aspects which I hope to include in these new paintings—and then select the THREE most important items—is my wish in the next few lines.

Lyricism
Fantasy of growth
Force of nature
X-ray of nature
Song of growth
Persistence
Diminutiveness of man versus nature

35

The uncontrollable
Dreams in Nature
Dignity, humility, sheer 'joie de vivre'
Sentinel qualities
The boundaries of life
Structure
Pattern versus Structure
Decorative elements of all that is 'SEEN'

Before describing 'SEEN', let me take the *three* most important aspects of this list—anyway for the next few weeks—and list them in order—as a guide to the new paintings.

1 X-ray of Nature
2 Lyricism
3 Song of Growth
4 Sentinel Qualities

SEEN. By this I mean 'understood through exploration'— seen, sorted. Anything *seen* has immediately its decorative quality—though its mood may be sad, gay, tragic etc. 'Decorative' need not to my mind be pleasing in the accepted sense—by 'Decorative' I mean insistence on some formal aspect of an object disassociated from its CONTENT. Ordered pattern divorced from its weight and full significance.

If art is the expression, to a great extent, of the sub-conscious—freedom from sheer representation is essential. This truism is easily written—not so easily understood until one's aims are clear. One must do more—much more—than use, say the nobility of a tree, to express nobility. One must of course paint nobility itself—and allow the subconscious elements to exert their influence.

The character of Objects. This is something that has long interested me—the essential *nature* of each object—its immediate character. If, as is often believed, the seeing of

36

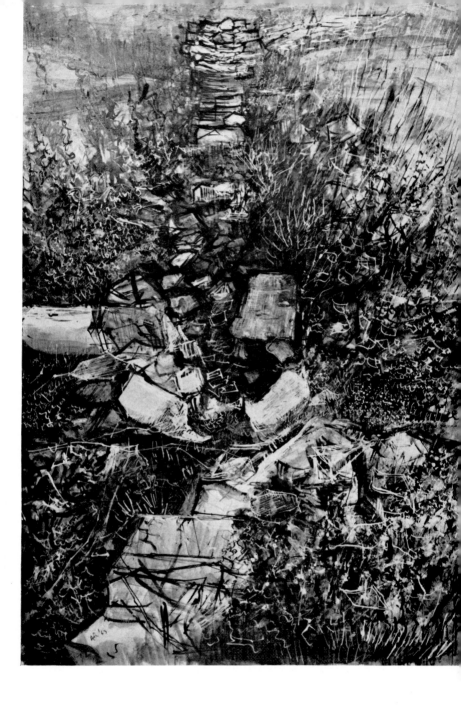

SNAKEDEATH WALL (see p. 17)

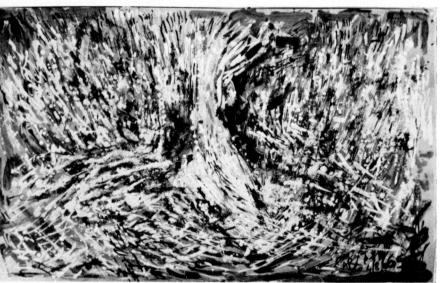

Above 'UP AND OUT!' THE RAINBOW ANCHOR SANG (see p. 24)
Below CORNTWISTED SISALSTOOKS OF GOD'S CREATION (see p. 29)

'things' in objects, is the first sign of madness—then let me remain with the insane. This realization of an object's 'personality' is something which is inherent in my vision (alas often made mundane in too careful an exploration)— and I still believe the drawings I made before my first breakdown to be the most interesting ones I ever made. (Proud teapot, humble chair etc.)

> There was a child went forth every day.
> And the first object he looked upon, that object he became,
> And that object became part of him for the day, or a certain part of the day,
> Or for many years or stretching cycles of years.
> The early lilacs became part of this child,
> And grass, and white and red morning-glories, and white and red clover, and the song of the phoebe-bird,
> And the third-month lambs, and the sow's pink faint litter, and the mare's foal and the cow's calf.
>
> <div align="right">etc. etc.</div>

Walt Whitman

March 1960 Looking back upon it, May 1960

A month of intense work on the hedgerow drawings. Only one of these really satisfied me—out of some twenty. 'Burrington Combe' achieved some little success in the particular aspect of landscape painting which I am after. A few others nearly pierced the target.

But out of three months hedgerow drawing, and no oil painting, there did appear the germ of future developments. In particular certain realizations—which did not mature until May—though they percolated whilst working in the snow, wind and gales of early Spring. One thing I discovered, above all, and that is related to 'OBJECTS'—

hedges, apples, gates, cars, tables, etc. etc. The *character* of an object depends upon *two* things. (1) Its structure, both physical and plastic. (2) Its particular rhythm. Hence the difference between two apples—of the same family. From this basis and understanding my drawing leapt forward—*and vision*—which is merely a clear understanding of WHAT IS PURSUED.

May 1960

From the midst of blossom trees appeared a strengthened appeal to formality. A doing away with melodrama as it were. A must to return to STRUCTURE—to sculptural ideas. The theme of material versus nature recurred—my desk with its litter of letters, bills, pamphlets—blotting paper—against the lyrical beauty of nature. This theme has tempted me over many years—at last I think I've found the right moment—and the right approach. It's a GREAT THEME—really the only one an artist need be concerned with. The two great forces of life—in unending conflict. Material versus spiritual.

My desk overlooking the village of Litton—with Mr. Payne's butcher's shop opposite—and toy cows grazing above and all round us—is the most perfect setting for this theme—and I hope to start with it in June.

May 30 1960

I am so full of ideas—and the lyrical inspiration of the countryside has affected me so much—that I feel I must pause and think hard. Drawings are pouring out—full of lyrical rhythms and song. Now is the moment for immense self discipline and a clear target ahead. For I feel capable of the best work of my life.

Have encountered Mondrian in the past few days—and

feel that by reading his profound words—and studying his *disciplines* I shall gain a lot. I must keep my aims clear—that is important if this moment is to be seized to the full.

June A note against recent discoveries.

I don't find nature coherent—*until* I begin work upon it. The initial rhythmic sensations, when confronted by nature, are akin to music and poetry. No—not akin—they *are* music and poetry. From this melody—all else in the painting will depend. Some people call this inspiration. I certainly do—but it is useless unless attached to other matters of equal importance. And none of these moments of 'inspiration' would be possible without the preface of hours, days and years of less joyous work—search—for ONLY THROUGH THE SEARCH does freedom of expression, vision and expression become possible. The fulfilment of it only becomes possible by the greatest possible *search*—and disciplines—married to the inspirational moments.

Certainly believe in inspiration—for what else can be of importance in art without this? All depends upon it. Without it art is colourless and meaningless (Mrs. Oglivie's garden, June 2).

Saturday, June 4

Hard in pursuit of the 'breakthrough' in my oil painting. After three factors

1 Lyricism of nature
2 Certain abstraction and simplification of shapes
3 Limited colour and aerial perspective

fell between several stools—too large a palette. Limit tomorrow. Complete abstraction *not* my way—yet, if ever.

39

It's the *immediate* character of things that I'm after—at this moment—the instantaneous reaction one gets on seeing things—and KNOWING them. From this point I want to *experience* the sensation again *as* I work. I want to show the fullness of nature in *liberated* forms—which in themselves come from nature (ourselves and other nature) —and ARE NATURE.

This is where Action Painting interests me—and I intend to use this form of expression—but keeping a lot of natural forms—and aerial perspective up to a point. I want to weld visual delight with felt delight—and keep the literary content that is inherent in the subject matter.

A cigarette packet—must be a cigarette packet—in its particular context. The first flash of meeting.

And so with a cobweb. . . .

Sunday, June 12 1960

Over the past week I have completed my decisions concerning the next phase of work. This has emerged from the Spring Orchard paintings, my readings of Piet Mondrian and the impressive exhibition of Roy de Maistre. The work—all in largish water-colours (and smaller drawings) will be directed into two channels.

1 Summer Growth—an extension of Spring—expressing growth of nature in its fullest luxuriance. Peas in the kitchen garden, unripe corn—hayfields cut and uncut. I wish to contrast GROWTH and ITS FINAL DECAY.

 (*a*) Hayfield springing up—then cut and forlorn. *But peaceful.*

 (*b*) Peas shooting up etc. then their decay and ending.

 (*c*) Corn shooting up to 'laughter'—then the cutting.

2 On wet days, when unable to work outside—I want to commence work on the DESK THEME—the much used

desk with all the man-made objects upon it—smeared blotting pad, piles of letters, cigarettes, envelopes, oddments etc.—leading out on to landscape, houses, signposts, trees—nature in general—man versus nature. In this series I shall effect a river-like flow of materials on the desk—leading to the quieter stream of the outside scene. Probably flattening the outside scene into a sort of backdrop—limiting 3D appearance—to give greater accent to 'man's objects' opposed to God's—or nature. The drama will be played on the desk top.

The more I work from nature—the more deeply I understand the beauty of the Psalms—particularly such pieces as 'the Corn shall laugh' etc. Although it may now seem obvious through the experiences of life in general— and particularly as an artist—the contrast and necessity of black and white, unhappiness and happiness, growth and decay becomes something rather profound. I wish to express this in my work—the growth of nature through winter (the waiting period)—Spring (hope and dreams of fulfilment—Summer (full growth, maturity—splendour) —to the Cutting Period when the laughter and fullness is over and the Corn must be reaped. It is somehow expressed so perfectly in this cycle—the laughter—the tears. The depth of it all.

An ambitious target—but the one which has appeared through seven or eight years of working at landscape.

Saturday July 2

Since the last notes—my target has become even clearer, Growth—The Desk—and how really to treat it. I still need drawings and water-colours of the present moment of Growth—but there MUST be experience of the actual growth—rather than just 3D effects. For these will be the studies for the large paintings I shall embark on, in

oils, in three weeks time. Also needed are studies and notes of road signs etc.—another symbol of man's work versus nature—and *what* symbols!

This afternoon, the whole of this became clear to me, as I worked down the road—with the 'released from 30' sign springing up from the grasses and hedgerow. What a struggle it was having! And what a swift symbol of man (get there fast) it appeared against the slow and sensuous curves of the cut hay and the abundant springing grasses and weeds. I tried to keep philosophical thoughts from my mind—but I could not help feeling continually, that there was a moral there—as always—in nature. Not that 'nature must always win'—which I used to feel—but that we must compromise and learn *from* nature—neither conquering each other—but living together. One can read nature like a book at such times (more so than a flickering fire, which is destruction most of the time)—one can read it as Gypsies read palms of hands and soothsayers look to their omens and signs. It is all this really, in nature and then in ourselves—and if we can *really* learn from nature (see how a cat relaxes)—man can emerge from this material struggle—the wiser and deeper. Anyway this is what I am learning—and I should like to express, visually, what I have discovered. So it will be the desk spreading forwards, flowing streamlike carrying man's problems and work, against the background of natural growth—and painted on a cross formed canvas—itself a symbol of suffering and anxiety.

It will be treated more freely than I had supposed a fortnight ago, but still representational in parts—using modern signs, symbols etc. to convey the effect. But the painting *must* be visually more important than philosophic or literary.

Monday July 4

Commenced work on 'The Desk theme'. A sort of road to Calvary—the stream or road, of the desk flooding through to nature; on the 'road' are all the man-made objects and trials—and as I work I feel the tensions and struggles intensely. Something should come of this theme —it's been in the pot a long time.

November 1960

(Though I attempted and struggled with several canvasses—my theme did not materialize. I have not yet reached the point when I can tackle this subject—but it is still my objective.)

Author's note—January 1968

Although the projected Deskscapes did not work out as I had hoped for, during 1960, one of them became the bricks for 'The Pen and Brush that leads to the unseen season of our souls through the winters of discontent—to the springs of hope. . . . 1962'—(worked in gouache and conté, owned by Iain Hamilton Esq.).

Another large Deskscape, born from the bricks of 1960 desk drawings, became 'Evening Desk, Litton 1961' (owned by The Reading City Art Gallery).

Sunday, July 24 Barrow Gurney Hospital 1960

The desk theme is started; alas I have to stop work for a little time, due to over excitement and the passing of my talent into something not quite controllable. But I can still use this time, I feel sure, for lyrical drawings and paintings—from nature—pursuing the rhythms and contrasts of textures, values and qualities which are needed for the desk theme. It is a bitter disappointment not to be able to work on the actual theme, in oils, but this I must resist until I am stronger.

43

Meantime, water-colour, black and white drawings, must serve my purpose—and these I intend to start to-morrow—however stumbling they may be until my full talent and energies are returned.

Reading more about Samuel Palmer—it is no coincidence that my interest recently has gathered round Manley Hopkins, Wordsworth, Lawrence (D. H.)—Walt Whitman. This is the world where my own work lies—this I am certain about.

September 15 1960

Started painting again after the holiday. Returned to 'realism'—in oils and water-colour—to renew the search into nature.

But I feel more and more the need, in combination with pursuing natural effects, to embark on more abstract ideas. That is to say—a more abstract way of expressing Growth—and yet retaining the image. It's the 'Immediate Image' with ALL its associations (for me) that I am after in the next phase of work.

I do not believe in totally abstract painting. I think this avoids the image as necessary in painting—but I do believe in the abstraction of art—for that is the only way one says anything.

November 4 1960

The first nine months of this year have seen a further probing into nature—with water-colour drawings and a series of oil paintings concerned with GROWTH. That I failed with the Desk Theme is not surprising—considering the ground required to be covered—and the weeks necessary to this after my breakdown of last year. This nine months has been needed for sheer hard work—searching

back into nature and finding one's form again. The Desk Theme needs perhaps a year or two of this search—before it is possible to approach it. My hospitalization this year meant a break of some importance—and one lost more than just three weeks. The fight is a fierce one—but the only one, in art, worth fighting.

November 23 1960

Again looking back. One must look back as much as forward—in the constant search. Again I find it necessary to make clear, to myself, what the aims of the next few weeks must be. As Ingres wrote:

'*Invention* is one of the prime marks of genius; but if we look to our experience we shall find that it is by making ourselves familiar *with the inventions of others* that we learn to make inventions of our own. The greatest of Nature's geniuses is not rich enough, in himself, to body forth all that he needs from his own resources. He who does not wish to draw upon the contributions of others is soon reduced, in his penury, to that most miserable form of imitation; the imitation of his own works. He will find himself obliged to repeat, once more, what he has already repeated several times.'

How true this is. Consequently I familiarize myself with Rembrandt, Soutine, Van Gogh, Vlaminck, Cézanne —recently Lundquist—to learn from them. But I practise only Rossiter—any search, however humble, into Rossiter's problems, loves, knowings. . . .

When the wine is decanted, there must be a fresh fragrance, a new taste—a perception, tuned by the past and orchestrated by the present.

The next stage is certainly one of SIMPLIFICATION; heeding the realism less—allowing the abstract to play a greater part. The initial contact—*which is always an abstract*

45

one—must *not* be suffocated by too literal a rendering. Cézanne said: 'I do not copy nature—I translate it.' Or was that Turner? Translation, to be successful, has always needed *complete* understanding of the first expressed form. This is why I persist so much in this stage—to understand completely the first expressed form. Then I shall be able to translate freely and with conviction.

One paints a wall, in, say, a partly cut field of silage (the last landscape completed)—not as a wall in a field— but as what it expresses in that first flash of contact. A snaking dark shape twisting across growth and ungrowth —a river conve ʻqing swiftly on a point—its power radiated outwards, east and west, the river suddenly stopped—flashed away like a ball from a batsman's bat— only both ways at once. *There* lies the abstraction—*all* else must relate to this initial concept and understanding —and it is in the later stages, when the initial inspiration (or *idea*), has waned into more mundane forms that the danger lies. Then, one so easily begins copying—'is that field quite right'?—'could that fence really be there?!!!' etc. The point is *they must be there—for the painting's sake* and *NOT REALITIES*. For one is making a *new reality*.

This is just where I go wrong so often at the moment, losing the first idea. I must contain it and refuse to compromise— imitating nature.

December—just after Christmas, 1960

Realized that the Desk Theme—Spring Desk—*had* materialized. 'Spring Desk'* is, I am sure, my best painting to date. Now that it is dry, worn a little and matured, I realize how it has come off and expressed something of what I am pursuing. At the time, with the mid-year set back and tensions, I discarded these paintings—and left only 'Spring Desk'. This I regret a lot now; nevertheless it

* Now owned by the Royal West of England Academy.

46

is good to know that the intense work, and suffering, needed on this theme WAS worthwhile. Consequently I am embarking on this theme, full bloodedly, for the next few weeks.

Already three are on the boil—to a whistling start.

Extracts from 1961 painting notebook

Sunday, January 1 1961

Desk theme well under way. Worked last Thursday, Friday and Saturday full out on three paintings—landscape desks.

It's coming all right—I keep two or three going at once so as not to lose the initial impact, to avoid banal representation. This method seems to be bearing fruit. A fine start to the year; hope to have six or eight finished in next ten days.

Wednesday, January 18 1961

A host of work in past seventeen days—desk theme well under way—hospital series started too.

My way of working is now clear. What I want to say lies in three categories—all to do with 'man's rhythm' against 'other rhythm'.

1 Desk Landscape. Man against nature.
2 Hospital Ward. Man's *accoutrements* against deeper rhythm of life itself. Life/death.
3 Train Crash. 'Man's disaster' against the fullness of life.

In all these I want to express my intense love of LIFE— in all its aspects—even, *not* despite, the tragedy and unhappiness of life. A song is orchestrated, for me, by

47

literally almost anything—anything which has a vital impact. I share Dylan Thomas' love of everything—I find myself in harmony with much of Hopkins. The song must 'out'—and the song for the next few weeks is stimulated by memories and recordings of the past ten years.

I find I work best at high speed—when the initial impact is still with me—but am only able to paint at such speed because I 'know' my subject, have drawn it countless times. *And 'loved it' from the start.* When love goes out of a painting it is finished. But like human love— there is much that has to be 'worked at'—to quote—it doesn't all happen in bed! And that is the most difficult part of 'perfecting love'. This must be done. But I still believe the initial love—the greed of love* as it were—is *the* important factor in life—and therefore art. One must love everything from a flower to a blotting pad—and back to a bedpan. Only then is one honestly in tune with life. And it is LIFE which matters in all art—not just vitality—life—and therefore the paradox death. Life and death are very closely linked—more than by just sixty-odd years. The paradox is hard to explain—but it's there. I suppose because without Death, the great unknown, Life would not be so vital or important.

Anyway back from philosophy—to work!

> Desk
> Hospital
> Train Crash.

January 20

Since submitting my work—mostly recent—to London for a possible showing in future—several things have

* Author's note: January 1968. I now realize the *dangers* of 'the greed of love'. I would change this to 'the NEED OF LOVE/GRANDEUR OF LOVE'.

emerged. I want to guard *against these*—at least some aspects of them. The fact is 'Dying Shoes, kissing Flowers' (re-titled 'Hospital Ward—Self Portrait 1961') seems to have hit the mark in several quarters—and I want to be sure, absolutely sure, that the flattering effect of this particular success does not lead me *astray*. Or influence my future direction for the wrong reasons. A leading gallery is interested in this aspect of my work—I wish to analyse why, if it is, this particular painting is so much better than the rest. I don't believe it is better than 'Early Morning Ward'*—though of course less ambitious. 'Easier'. (Both to digest, look at and paint.)

What *are* the qualities which make 'D. Flowers . . .' so much better than the rest?

I think, and I am bad at analysing my own work, that these may be some of the reasons.

1 The simple, direct rhythm of design.
2 Texture of varying parts.
3 Simplicity of treatment of objects.
4 Hint, but not too much, of literary quality. (I *do* want this.)
5 Colour—siennas, whites, greys, greens, black-greys, greens.

And how does this compare with the 'Early Ward'?

1 Not simple design—direct Baroque rhythm.
2 Texture (and part linear drawing) interesting.
3 Objects treated simply and more *sophisticated* than 'D. Flowers . . .'
4 Definite literary quality. Part of its drama.
5 Colours—controlled—siennas, blacks, whites, greys and more local.

* Author's note: January 1968. This quick note was a mistake. 'Kissing Shoes and Dying Flowers' is correct title. Now owned by Bristol City Art Gallery.

49

This is how these two paintings seem to compare and vary. I have no doubt they are the best to date of my work.

Now for the future. I must hold on to these qualities and be a little less 'effusive' in paint, a little less ecstatic—a bit more controlled—thought out.

1 Work from objective still lives again.
2 Contain rhythms a little.
3 Limit colour to present palette:
 Black
 White
 Yellow ochre
 Burnt sienna
 Viridian
 Cobalt
 (Lemon yellow, cadmium when necessary.)
4 Work at speed after much thought. But allow intuition to play the upper hand DURING THE ACT, after a lot of thought and preliminary sketches—drawings, oil panels etc.
5 HOLD ON TO THE INITIAL IMAGE—THE IMPACT—BUT SEE IT THROUGH WITH MORE REASON AND KNOWLEDGE. Simple, everyday objects which I love—pots of paint, paint sticks, boxes, flower vases, old shoes (flowers amidst the debris) etc.

And so emerges a fourth theme.

1 Desk.
2 Hospital.
3 Train Crash.
4 Man's delightful debris—with nature's growth *insisting* through.

Death versus Life. A constant idea in all subject matter —it cannot be avoided—it is necessary to count it. This

great paradox lies at the root of all life—all our doings, happenings and decisions.

The love, the absolute zest, for LIFE.
—The subconscious longing for Death, the great unknown—the great 'fear'. One plays as zestful a part searching this, *unconsciously most of the time*, as one does life. The two are inseparable.

I do *not* believe in finality at death. God knows what I believe, but not this. All art seems to prove it to me—and Growth itself. How this loves a refuse dump.

January 24

Look—we have come through!
The little wren twittering in the twilight,
The wan, wondering look of the pale sky,
This is almost bliss.

And everything shut up and gone to sleep,
All the *troubles* and *anxieties* and *pain*.
Gone under the twilight.

Only the twilight now, and the soft 'ah' of the river
That will last for ever.

And at last I know my love for you is here;
I can see it all, it is whole like the twilight,
It is large, so large, I could not see it before,
Because of the little lights and flickers and interruptions

Troubles, anxieties and *pains*

You are the call and I am the answer
You are the wish, and I the fulfilment,
You are the night and I the day.

What else? It is perfect enough.
It is perfectly complete,
You and I
What more—?

Strange how we suffer in spite of this!

D. H. Lawrence

A brush of a trouser, the closing, snap, of a wooden box—a tune that pipes . . . inhaling deeply in the early morning—dipping a pen into the small vestibule hole of ink—posting ten letters in a pile—through a narrow box— all these constitute their own magic. (In one week I painted, or started, 12 oils, 3 drawings and a mass of sketches.)

Friday, January 27

A very hard month's work indeed. And I know that I am on to the right theme—at last. Roy de Maistre's encouragement on the recent canvasses gave me good heart. It is good to know one's work is understood— though one only paints it for oneself. Finally—all decisions are one's own—and one is deeply 'involved' (as Bob would say)—deeply involved in life!

The fascination of the world one surrounds oneself with—consciously, unconsciously and by chance—*this* fascinates me. I find a pattern running right through it all—a hospital ward, soon, in one's own vicinity—even beyond—takes on the same pattern as one's desk, one's room, one's life. So the thread is woven—and by imagina- tion, courage in one's beliefs and abilities—one makes from the world—a world of one's own. Not divorced but wedded to the main thread. My desk—my pillows—my

typewriter all *make* the world—the world we know and see. God makes the rest—and the two are in perpetual conflict. Only when resolved is there happiness. Hence the urge, for the deeply religious, to free themselves from wordly things.

If one is not of this mould—one MUST use these 'wordly things' to express greater matters—because they can and do express them. There is joy and sadness in anything—for it is made by man—and hence by God. The two, like life and death, are inseparable. Of this I am sure. This is what I'm after in my present work—but NOT in a literary way—in a full blooded, paint it all, way. Not an easy task.

February 1

Continuing theme—so full of ideas that I have to discipline myself strictly—before starting work. But the work is growing.

February 5

Started new paintings during the week—but left them in a very fluid state for the future. Sunday afternoon—mostly 'thought' on the next stage forward—to effect the most powerful, and yet simple, images for the desk and hospital theme. To avoid banality—and to effect the 'glory' of these things. The temptation is to work more freely—less representationally—but I *know* this is wrong at this moment. I must see this present series—anyway next four paintings—through in the same way as I did 'Spring Desk'—the accent upon the 'things' and the spirit of them. Goodness knows this is difficult—when the spirit is there—the other is missing and vice versa. I must keep the two wedded together. Oh what a struggle.

A day in bed—after a busy week with fire in the kitchen and 'flu in the family. Felt rotten since Wednesday—so that today's rest in bed is doing me the world of good—both the chest and mind needed resting. Oh such a lazy day! Black pussy slept all day amidst the landscape of my bed—Anneka and Annalisa lunched in the bedroom—and the air was gentle and soft. A. gardening as I write is bringing her strength and peace to the family—what a girl she is! Annalisa bobbled about in the garden—and there was the feeling, in my bedroom, that the whole world was resting. A Beethoven concert, some verses of Robert Graves—a sleep in the afternoon—no work, just relaxation. I must try this tonic more often. My mind is full of images—in the past few weeks I seem to have lived a lifetime. This is due partly of course to the themes of my paintings—looking back over fifteen years—using the experiences of these years—trying to express them in a finite way. Now, as I lie in bed—with the bric-à-brac of just one day's things around me—I realize again the pre-occupation that began in hospital in Greece in 1946 and fascinated me during Roehampton days. The 'life' of things around one against 'other growth'. (Author's note, 1968. At this time I had no thought whatsoever of writing *The Pendulum*. This was put in mind reading Huxley's *The Doors of Perception*—I think in December 1961.)

Today the trees are bare—biding their time. . . . Annalisa hands me my watch—perfection of movement breaks the train of thought.

And this evening a talk on Thomas Traherne. The discovery of this great mystic poet is a happy coincidence this evening. I believe so fervently in the mystical side of art—any 'deeper knowledge' that I may possess stems from these experiences—and even if it leads at times to

Barrow Gurney*—it is still Divine. It is unreckonable, illogical, indescribable (for me)—but the source of life. During these experiences one is aware of something *so* much greater and more lasting than oneself—one is, for a short time, in communication with angels. The sky, the trees, the stream, my blotting pad, ward pillows, Beethoven, the movement of a child all became fused with the same light.

Continue on Thursday with 'Dawn Desk'—and imbue it with these images—that is my aim.

February 28

A great spurt of work in past two months. Out of the rut—into something deeper than I had realized. This evening, after teaching, started work on the 'Casting Room' which has become alive with tragic figures—the casts, a glory of white plaster, twisting in shame—humiliating and terrible. There is 'glory' in everything—this I believe fervently—but what a testimony against the glory man sought in war—are the wards of a military hospital. The only glory left is the passion of feeling it arouses in one—of *sheer anger*. This I wish to reflect in this series of 'Cast' paintings—the *shameful glory* of war. As the casts for 'future men' lie static on the tables—there is an echo of some deep voice saying . . . saying oh so much. There, in that room, is a complete testimony against war. But whilst painting, my mind has become full of other images—images connected closely with hell . . . and then one remembers. Man makes other hells besides shells, bombs and mutilated forms. He makes hells in personal relationships, the prying of one man upon another, the laugh in a corner about some other person—this can damage just as deeply. How man likes to hurt and humiliate man. The nervous twitch, the asylum, the lost world of mental

* Somerset Mental Hospital.

hospitals—all these are made more possible by MAN. Somehow there is something more honest about 'mere' mutilated bodies! And then one remembers the two things go hand in hand—where any hands are left!—and one should be left with a feeling of entire pessimism. And yet I find I am not—for there is some 'glory' beyond all this—the sprouting rubbish dump—the worn penicillined interiored shoes—the train crash—all these somehow prompt a song which extends beyond worldly suffering. And in words this sounds clichéd, banal, absurd—but it *is* true. One must probe deep—look deeper and deeper— grovel around for a meaning—for it *is* there to be discovered. And one can only meet Peter, straight in the eyes as it were—if one has tried to do this. One's attempts may be puny beside the great—but it is the effort which counts—the constant struggle after truth. And so back to the 'Cast' painting—an unholy subject matter, but somehow tinged with something greater than man's folly— For there is always something to marvel at—those casts are a marvel—in many ways. If they can lead somewhere—then *there* is the glory. A sort of obvious signpost. . . .

April 1961

A rest of a few days over Easter has been necessary after the full out period of painting from January to March. I felt almost torn to bits by the effort—but satisfied that I have progressed.

Now for a fresh batch of paintings—mainly dealing with Spring—both in growth and its decay. Sprouting gardens, flowers, weeds etc.—then their laying down.

More still lives of well worn objects—ladders, boxes, plants . . .

Some landscapes incorporating man-made objects

(barns, fences etc.) against spring growth—wild daffodils.

I hope also to finish the two desk paintings started six weeks ago—and the large Hospital Ward with bed table across foreground. These I must keep simple—with the 'largeness' of the small pillow sketches; must not overload them—this is the tendency I must hold out against.

One more thing I have learned recently. That it is a mistake to concentrate on one particular theme, to the exclusion of others, for too long a period. I must switch from hospital to still lives, back to landscape—then to growth. Then I can keep the initial 'song' of each painting—I so easily overdo a painting and thump my point home—unsubtly.

But the important thing is to keep working, looking back constantly at the great masters—learning with each canvas.

Spring is a fantastic time to work in—frighteningly so at times. In May a series of blossom trees I hope. . . .

April 29

The first flash of seeing—the first emphatic 'song' of a subject matter—is what starts me working. This is something I wish to capture in my pen sketches—the abstract essence of the scene and its emotive content. Similarly in the painting.

The reality must then be forgotten, sacrificed to something more important, the abstract structure of the painting.

Certain scenes and shapes, objects and arrangements, prime in me such feelings for work (and unrest)—that I feel a physical demand to work. I feel drawn to these shapes—despite myself—at present there are hedgerows, old boxes, trees etc. They express certain matters to me—quite apart from their realistic content—and one is aware of something deeper—and through a working period of

57

months (on a particular subject matter) a certain philosophy materializes. A philosophy drawn out of oneself—despite oneself.

All objects possess their individual moods. Sadness, gaiety, pathos, tragedy, exhilaration; this mood is what I wish to extract and re-state in my painting.

I like Reynolds' comment, in his last Discourse, when referring to students. 'I must confess that it is not absolutely of much consequence, whether he proceeds in the general method of seeking first to acquire mechanical accuracy, before he attempts poetical flights, provided he diligently studies to attain the full perfection of the style he pursues.'

Sunday, May 14

Completed further 'Still Life'. This series, starting with 'Kissing Shoes and Dying Flowers' has now absorbed the best part of this year and I really feel I'm getting somewhere with it. I want to express in these animated, sprawling objects—their dignity, their quality, their 'breath'. I believe more and more in the 'quality' a painting (or any work of art) *must* possess. This is something quite separate from technique. It's the 'quality' ('essence' is a good substitute word) that turns a mundane work into one of poetic values. The quality or essence of the subject matter must be injected into one and then into the created thing. A work of art must breathe, sigh, sing, dance—stand majestic—and STAND ALONE, quite apart from what started it off.

It's a frightening business painting—and the loneliness and sadness that overwhelms me during a painting is something I find hard to put into words. But this I shall try to do in my short stories which I hope to start when this batch of paintings is over.

One is always so far from one's goal—so unsatisfied with what one has said—for one has said so little. That is what drives one on to more work—trying all the time to say something more and something deeper. I believe a painter's job is to examine, X-ray the surface of things and thus penetrate deeper. The surface reveals all—if one 'looks all round it'. The surface exposes the skeleton and the underlying truth—to a perceptive eye.

Paint—this must WORK—this must be something poetic and out of the ordinary. It must speak magic words— make mystic signs, dots, dashes—all of which add up and are related to life. That is why I draw so much—to keep continuously in contact with nature's growth and ways. We can learn only from nature as artists—the soul and spirit are watered by nature. So many 'artists' these days want it the other way round—to water nature. That is the gardener's job—we must let nature water us. Artists working loosely, in the dark, in the 'abstract' (often, not of course always) work the wrong way round. They seek to impose stereotype rhythms and forms on their can- vasses—unrelated to natural growth. Their work is conse- quently, *however decorative*, quite without feeling or deeper meaning. Highly suitable for curtain designs—floor patterns—but not paintings.

I believe soon there will be a return to 'naturalism' (what a horrid word)—a return to the object and its inspiration. We are bound by objects, hedged in on all sides, and these objects are the starting off point for all visual art—whether it be a head, a wooden box, a gate, a dying flower or a pussy cat. Or so I believe and nothing will dislodge my love and respect of the object—as a mani- festation of something much deeper.

Sunday, May 27

How things sit—how they lie—how they behave in relation to one another—that is my concern. Soon I expect to return to the desk theme, for in that there is the idea I wish to use most fully in my present paintings. Still 'man versus nature'—but more broadly painted—less hammered home. 'Spring Desk' says some of the things I wanted to express—as also 'Dawn Desk'. Except for 'Stormy Cornish Desk' (and the two just mentioned) I do not feel I have said anything of consequence in the desk theme.

I shall not be able to work for ten days or so—due to a London visit and teaching—a good breathing space before setting forth on fresh paintings.

> Summer Growth and Desk
> Garden Growth and Desk
> Corner of the Garden.

Sunday, June 25

Finding it difficult to paint—heat, impending birth of our second child—really feeling unproductive. But *this* is the moment to keep working—plodding away those same hours in the studio. Whatever the result. This is the only way an artist continues to produce work—through the dark dejected days—still struggling without 'inspiration'—and then suddenly the tune will return—and things will flow again. Working not to express one's sorrow and depths of despair—but just working for the sake of keeping going.

Some notes on desks. Sunday, June 25

Early morning light on desk.

Objects lit from right—diagonal lighting; background quieter in tone—occasional lighting of wall top, trees etc. Window ledges lit. Window bars ½ tone dark against darker background. Desk top *dark*—diagonal lighting. Flowers light against dark green of tree. Dark blue against paler wall.

The scene as a whole—Early Morning Summer Desk— is of a plateau—fresh and unawakened, with forms upon it kissed by piercing light. The light rides across the plateau diagonally, catching corners of paper, books etc. One tall pile is lit dramatically against background. The scene behind is quiet—occasional soft lighting of walls, rooves etc.—but the tonal scheme is subdued against the bright desk; and the desk is bright because of lit paper and books and the contrast of the dark desk.

There is a freshness to the scene—one understands that these rays will move in, soon, and the desk will be un-illumined again. But for a moment there is stage lighting in the foreground scene.

Wednesday, November 22, 4 a.m.
A long pause in writing. Work of first half of year finally breezed out of me any desire to work in a Baroque or flamboyant gestured manner. Certain of these largish still lives came off—particularly 'Bottles' and 'Kissing Flowers and Shoes'.* But what has materialized is a keen desire to work on a much smaller scale—with the same simple down to earth objects—*seated in calm.* I now want to direct my energies to effecting *calm* and *order*, of a classic order—in impastoed and highly varied qualities of paint using an earth restricted palette.

There are now four main themes in mind.

FLOORSCAPES.

DESKSCAPES.

* 'Kissing Shoes and Dying Flowers.'

61

PALETTE SCAPES/WASTEPAPER BASKETS/PAINT POTS.
LANDSCAPES . . . Walls, ditches, hedgerows.

I want the paint—thickly and slowly encrusted—to speak a double message—one of reality, paint pots upon a coarse wooden table—the other abstract; that is abstract in the quality and variety of the paint itself—which through its thickness and build up will produce the 'form' of the painting.

My eye and spirit is enchanted by all it sees—whether it be a misty November evening, or a 'something there is that doesn't love a wall' kind of wall, or merely a few empty jam jars, paint pots and stains on a floor.

I am sure that by using these simple earthy, well used objects—I can get over my delight—and something deeper. The relationship between man and his man-made object.

Off to a good start with

> Corner of my palette.
> Corner of my studio.
> White paint pots.
> Studio Floor.
> Studio Desk.

Ironically—the one painting which I did not exhibit in London (Paint pot and flower pots) has really proved the only 'stayer' of the last year's work—and the real clue to future steps.

The struggle is sometimes unbearable—and darker than one can face easily—and yet at times, like this, when life is singing—the veil is lifted and one can once again take a few tentative steps forward. At least one hopes that *is* the directional tread of one's heavy boots!

Oh to sing and love and breathe and paint—and just be. It's a very great privilege.

Friday, November 24, 2 a.m.

Continued painting after a fine evening and dinner at John and Willy's.*

I know that *at last* I am on the right track—with the four paintings on the boil at the moment. Two 'wood' ones—'white paint pots' and 'Studio floor'. At last I feel I'm saying something personal and in a personal way. I find myself, at last—painting as I first did at Eton—with thick encrusted paint built up slowly layer upon layer—to maintain the glow. And a very limited earth palette. It's a good feeling—and I am pleased to have been asked by the Leicester Galleries to show one in the New Year—it must be a really good one.

The build up of paint—each alternate half-hour—becomes abstract and one is in the realm of pure poetry. *This* is what painting is about. The subject matter disappears and reappears—like the sun behind the clouds—until one finally feels one can leave the sun in peace to singe the body. In painting—the mind and eye—I really never know in which order—I think the eye, on looking at a painting counts more than the mind—but in painting both must work in equal harmony. Or you get a Bratby—all eye and emotion and paint and no intellect. (Even so they are rather stunning—as large virtuoso illustrations of his particular way of living. One must not underrate him—he draws quite excellently. And of course I love his unlimited energy.)

Back tomorrow to these slow steps in a direction I'd almost forgotten—immensely rewarding—and the paintings really are advancing. At times they look quite beautiful—at others rather dirty. But something's sure to

* Dr. John and Mrs. Willy Pinching. Dr. John Pinching is our General Practitioner in Wells, and has aided us, quite marvellously, over ten years.

come out of this series—it's serious stuff and no nonsense. And truthful, by God, I hope.

The pendulum of my mind does not often swing too far, most of my days are spent free of its vicious swings.

In the second part of this book I re-create my surroundings, feelings, thoughts, and actions when the pendulum had swung too far out of orbit and I was resting in a mental hospital—partially out of contact with the 'reality' of the world. But even this period—some three years after the last entry in the 1961 notebook—possesses for me a 'reality'. It is difficult to define what 'reality' in fact is. Certainly those months, at times, held me spellbound by *their* reality and significance. At this distance one can very easily discern the truly disorientated days of that period. And leaning heavily upon the shoulder of that great poet, John Clare, I can repeat—with a deep sigh: 'If life had a second edition, how I would correct the proofs.'

Part two

The melting voice through mazes running;
Untwisting all the chains that tie
The hidden soul of harmony.

Milton

Chapter one

The whole world now seemed to need my comfort, care and consolation and I poured out compassion to the world at large as a bellows belches out its air. A period in hospital was recommended. But I did not care. If this was to be, so it must. Inside those walls I would bring what comfort I could muster to those troubled minds and souls. If I am going mad I thought, it is a strangely good sensation.

I had known for a long time that the not very quiet desperation of my friends and colleagues betrayed a madness in which I had no part. If this was madness, framed by the simple bare room with just the bed and window, it was what I had been seeking for a long long time. I turned on my side; the pain from the injection made me twinge. It was echoed by a rust mark on the light wall. This compensated for the austere framework of the door painted a colour somewhere between yellow ochre and green. It all fitted; the colours, the hint of damp on the walls, the rust mark; the creaking bed. The dirty blankets were so much part of myself that I did not want to throw

them off. Instead I turned on my back and stared at the ceiling. The smells which percolated under the door, stale urine, tobacco and old men melted into me and filled me with a sense that all was, at last, at peace with the world. I remembered old men in the East End of London sitting on Park benches, their fly buttons sometimes undone, rolling pinlike cigarettes with the care of a gardener tending his roses. The paucity of the cigarettes had only hurt me in the way that a meal missed one day was made up by the next. Early on in life I had learnt that everything is comparative—missing meals, lack of money, pain, death—humiliation. There comes a point when nothing more can wound so deeply and anything like a Players cigarette is handsome reward for the other days lacking in plenty. Then the need for success had bitten into me, the desperation for its continuance after one or two small rewards had become an obsession, a disease swollen to such proportions that everything I really loved and believed in had evaporated. No, this is not true. Much of it had pleased and delighted my ego.

But here in this sparse, silent room I wanted none of these things. The sagging bed, the scarred walls, the blankets and polished floor boards were all I required. It was marvellous to lie here and just think, to turn over in bed and just think. . . . Outside I could hear slippered feet, limping paces; brisk voices. The ward waking up. I felt a part of it. My door opened and a male nurse entered the room.

'Morning Mr. Rossiter. Did you sleep well?'

'Yes, thanks. Very. Very well indeed.'

'Well, you'd better stay where you are for the moment. The Day Charge Nurse will come and see you after breakfast.'

'Thanks. Thanks so much. What's the time?'

'About six.'

'What time's breakfast?'

'Around eight. Just you relax and get some more sleep.'

The anthropomorphic overtones of all I saw and felt had been a marked characteristic of my earlier paintings and writings. Some literary friends had attacked me for this; but I had never fully understood their points. The link between man and the objects he fashions was not only obvious; it was also necessary to *express* this. It seemed to me, even now, mere conceit and presumption to disassociate man from the matters, problems and things he had created. If man was allowed to be 'part' of the atomic age and conception and Vietnam, why not part of a cornfield which he had sown and the gate he had built to enter the field? Life is so bloody dishonest; one set of thoughts and actions approved, the other shelved; at the best 'disallowed' by convention; worse still by the critics who symbolized convention disguised as free thinking, progressive intellectuals.

I had not noticed the light switch before. It was a simple one, turned up at the moment. It looked snooty. A thought occurred to me. The snooty, turned up switch was doing nothing. It was useless. Turn it down, humble it and the room would be flooded with light. I laughed to myself.

The door opened again. A young female nurse appeared. Strangely out of place. She was carrying a cup of tea. She was extremely pretty.

'I've brought you a cup of tea.' She looked around the bare room, hesitated and then passed it over to me.

The warmth of the mug and her prettiness moved me profoundly. The simplicity of her presence and the mug of tea were something very special at this moment. I decided I was not entirely ascetic yet. 'Thanks so much,' I said again. A pause. 'Do stay for a moment.' I sat up in bed trying to close my pyjama jacket.

'Do you know,' I said solemnly, 'I believe a cup of tea

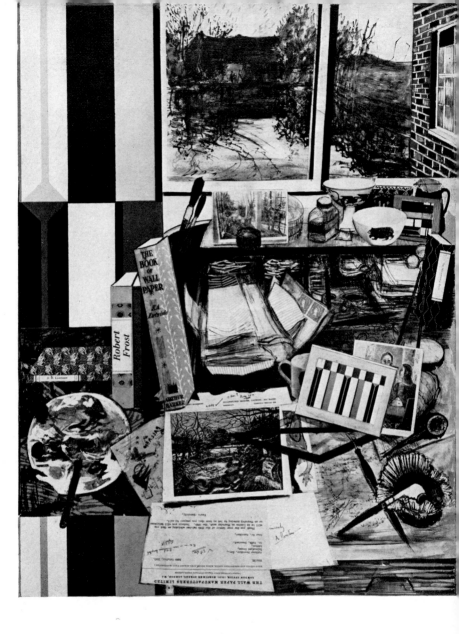

Desk collage (see p. 47)

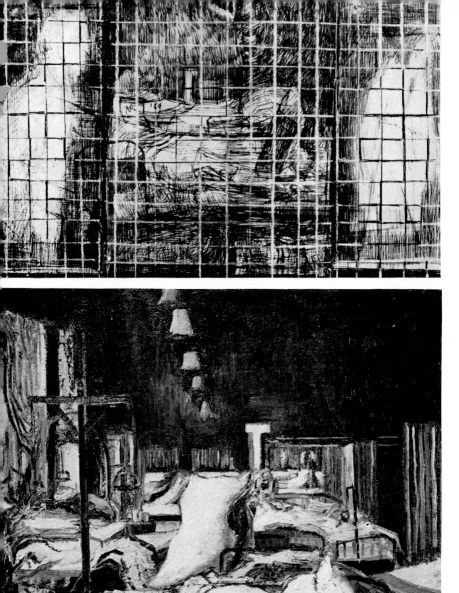

Above MENTAL HOSPITAL WARD [the figures]

Below HOSPITAL WARD } (see pp. 72 and 73

and kindness have served more between them than a thousand pills and operations.' Oh, dear, the old line.

'Oh, I don't know,' she said simply, 'it doesn't take long to make a cup of tea.'

I sat right up in my bed. I placed the mug on the floor and said, 'And how long does this kindness take to make?'

The nurse did not seem to understand. She was thinking, 'You're a queer one—an artist of course . . .' But she said: 'You drink up your tea whilst it's warm.'

'Kindness,' I said, 'takes more time to cultivate than a thousand cups of tea.'

'Oh I don't know . . .' She was thinking of her boy friend and what they'd done in the haystack; her father; his love of old cars.

'What's your name?'

'Nurse Parsons.'

'Your Christian name?'

She paused. 'Betty—Elizabeth really.'

'Well Liz—thanks—and remember kindness brewed on the flame of time makes for mended men.' I felt as I had, years ago, playing the lead in amateur theatricals, the audience hanging on each word of mine. Bloody hell, what a hypocrite I was. All I wanted, all, really, was to talk with this pretty girl, to make love to her—just as I had wanted to impress so many of my young students. My God—my hands were as dirty as any of them. . . .

'How long have you worked here?' I asked.

'A month. I go on to another ward tomorrow.'

What the hell prompts a pretty young girl, I thought, to work on this kind of ward?

'Have you enjoyed it?'

'Oh, it's O.K. But I'll be glad to be on Boundary Ward.'

'Boundary Ward?'

'It's a mixed one. Much cleaner than this.'

Yes I thought—it's the squalor that only appeals to a few. Dirty old men, like myself. . . .

'This is a sort of mad geriatric ward.' She spoke without enthusiasm but full of knowledge.

'Oh I see—yes I see,' I said. 'A bit dirty and all that.'

'Yes,' she said simply.

There was a long pause whilst I sipped my tea. The nurse took the cup and turned to move from the room.

'Well Liz—the best of luck—and thanks for the tea.'

'That's all right.' She pushed open the door; I noticed the curve of her legs accentuated by the white apron and dark black stockings.

Alone again. Marvellously alone but with thoughts rampaging as corn blown in a summer gale and lit by moonlight mists. My God I thought! I had longed to say, 'If you speak from the heart, you can't go far wrong'—or to quote Van Gogh's profound words: 'My judgment is human, reason Divine.' I knew so well that the two were inseparably linked; I longed, not from lust, but from perceptive passion to explain to this simple nurse what it all meant. 'You never can' I thought—'how often I've tried. I've talked, charmed, seduced all to one end, and *how many* really understand? Just one in a billion. How often, I thought, I've used phrases like: 'I hope I've spent nearly all my hate as there will then be good change for love.' And no sooner said, and applauded, than I'd hated myself and a dozen dear dead souls. My God what a hypocrite I was. All of us were . . .

Another hour before breakfast. The door again opened. A male nurse looked in, said nothing, retreated. The door was left open. I stared through the doorway; I saw some green curtains hanging disconsolately from a bar. The rings and ruckled curtains, although stilled at this moment, were busy with life and its problems. Two lone curtain

70

rings hung, disassociated, from the working ones. They were peaceful beyond measure. They had freed themselves from the body of the world and its work. It delighted me to stare at those two simple rings, on holiday, exactly like myself. On holiday, my suitcase and self packed with compassion.

Breakfast arrived. I got out of bed; once again I tried to tidy my jacket and trousers; I sat at an awkward angle to the tray set on the table. A piece of not fully cooked bacon and four slices of thinly margarined bread; a large cup of tea; the brown colour and warmth pleased me considerably. I ate slowly. The colour of the bacon compensated for its lack of cooking; I left it as long as possible on the white plate. The pinky red colour against the white were as perfectly matched as the dark, rich Fortnum and Mason jam which is served in rich houses at tea time, on Wedgwood plates, whose blue rims echo an eternity of Etonian peace.

The sun suddenly slanted through the high window lighting up the breakfast tray. The marmalade, triangular bread, cup and saucer stood amidst the ruckles of white cloth like majestic pieces on a chess board. The angle of my knife led my eye to the cup and the handle curve, down to the rind of the bacon. There was a unity of design which I had so often sought in my painting. When the sun withdrew its chiaroscuro, there was left only an odd assortment of crockery and unfinished food. I felt the disappointment which a child experiences when his favourite toy is broken.

It was about ten o'clock when a doctor and the male nurse whom I had not yet met entered my room. They made it seem strangely small. I noticed the fair, small hairs on the doctor's arm which reminded me of Chinese Painting. The economy of those hairs contrasted bravely with the ugly curve of the rubber stethoscope and the

dark face of the nurse, badly shaven, against the white of his coat.

'Well Mr. Rossiter—we're here to help you.' It was the doctor speaking. 'Right now I'd like to make an examination, nothing complicated; just a few formalities.'

The examination took some ten minutes. It seemed an absurd waste of time to me. Opening my pyjama jacket, lying on my back, breathing in and out, turning my head away so that my breath would not sweep over the doctor's bending face.

'Well that's all. Thank you.' A few moments later they both departed.

'That's O.K. by me,' I thought. 'Just leave me alone.' The silence that followed made its own points. I stared at the ceiling and let my mind wander aimlessly in a way that I had not done for a number of years. Lying on my bed, the luxuriousness of the simple room, the stained walls, the strange but honest odours filled me with satisfaction. If this was not life at least it was not death. Here at least I was free of the hypocritical world, free to inspect and love walls, iron bedsteads, triangular sparsely margarined bread and partially cooked bacon. I got off the bed and stood up in the small room. It was wonderful to be free in this particular kind of way.

I was not allowed my clothes the first day. Draped in an ill fitting thick dressing-gown, I ambled the long ward whose inmates dribbled and drooled the last years of their lives with just a billiard table to anchor them to some form of reality; the ward was punctuated by sawdust, urine and ceaseless dreamlike movements which played out the twelve hours of daylight in a fantasy more real than anything I had known since *Alice in Wonderland*, but close to the world of Kafka and the 'black Goya'. But I was happy. Nothing could interfere with this. I played billiards with a young man—an ex-convict—who had done

nothing worse than slog a couple of sadistic policemen who had pounced on him; the man had not eaten a whole meal in a fortnight; his desperation had forced him to fight back at a 'reality' that he could not possibly comprehend; whose force was more total than all the sonnets and poems, all the paintings and novels ever written. All the music ever composed.

I enjoyed those games of billiards. The sheer honesty and determination of the young man, so totally lost in this world of dreams and drugged figures, moved me strangely. I was moved too by the seriousness which the young man employed upon his cue, chalking it with infinite care. This was something I really understood. I felt a deep compassion for the young ex-lorry driver whose 'sentence' to this type of imprisonment baffled him. 'I'd rather do three months in the nick, bread and water and all. You don't lose your remission. You know where you are.'

As I became part of the ward I felt myself merely a punctuation mark on a long page of writing. A shorthand squiggle which only a few could translate. There were only two items I required—my camera and writing materials. The latter was easily satisfied by the Charge Nurse, a board with a clip at the top of it and a dozen sheets of Royal Insignated Hospital Paper. I added to this a dozen sheets of lavatory paper, for tracing certain patterns in the ward, and felt satisfied about this matter. I then sat down on my bed, which sagged and creaked with a seriousness quite in tune with my mood; I began to make notes of the events of the past few days.

Here in this strange ward, I no longer sought the ultimate which drink or drugs would bring. I also no longer felt the need to make jokes, to be the eternal clown,

the eternal Royal Knave serving a King and a Queen. As the Knave I had so often pipped their Royal Highnesses with a red diamond of an ace. This was good. I laughed to myself. 'Good', I thought; what the hell is really 'good'?

The click of the billard balls reminded me of the stream outside my writing room in Litton. Its rightness and reticence, its continuance through an action that demanded another, the flow. . . . My desk had been the same; strewn with years of letters, day to day thoughts; diaries crammed with memorable dates, the latest novel, piles of books and invitation cards. . . . Really it had been wonderful, not the messages of most of the paraphernalia, but the mere *flow of life* and *movement* upon it.

I looked out of the barred window. It was all strangely peaceful. Even a newspaper with the latest account of the massacres in Vietnam really meant nothing. The photograph of the recently arrested child raper. Well he looked like anyone else. The Press massacred him and then their 'Lordships' who, with speeches recorded so that they did not have to bore their wives recalling them, sentenced him to an institution whose terror and impossibility would have broken the soul of a saint; and all in the name of law, justice, order and man's rights! Did one of them know the humiliation of an eternal sentence with Hope dispelled after five years? They quibbled, argued, donned their wigs, their robes, made White Papers and even longer speeches about matters which affected them so little that they could return to their elegant flats and country houses, declaiming—'It's been a tiring day, m'dear. Most tiring. They really ought to have modern ventilation in the Upper House. I'm going to have a word with Freddy about it.' Then his wife would pour him out a whisky and soda; the attention accorded by a working woman! The slippers, slap, ironing, children and all would be substituted by a delicious dinner ('I'm so sorry the

oysters didn't arrive') and a large brandy and soda afterwards. . . .

Speeches, quotes from Donne, from metaphysical poets, Pythagoras, Danté, Blake . . . not a word or line really understood. Was I wrong? What one of them (and enough of them owned Impressionists and Van Gogh paintings) —what *one* of them had ever read those immortal, majestic St.-Francis-like letters of Vincent Van Gogh? One out of ten thousand. Mostly they pronounced death, gave life, took £10,000 a year and bought shares and large farms and considered Van Gogh a madman who sliced off his ear and painted 'emotional paintings'. Not one of them realized the immortality of a pure soul, a harbinger of profound inner knowledge, of *real* worldly humility practised in his work and his life. Rembrandt . . .

'My dear—do you know Charles has just bought that drawing of Titus?'

'My dear, how *charming.* How *delightful.'*

'Do you know what they paid for it?'

'Ten million?'

'Oh don't joke darling, be serious. *How much do you* really *think?'*

'Five million?'

'No—don't be silly; be serious for a moment. It's only a drawing.' Only a drawing. My God . . .

'Five thousand pounds.'

'Do you think any drawing worth that?'

'I just don't know.' A pause. *'Did you see that Bradman's bat went for seventy pounds yesterday?'*

'I'm talking about Charles's drawing.' Charles's drawing! The drawing belonged to heaven, hell and the world.

Then there would be a long silence, more drinks, elegance, peripheral talk, mostly gossip, about racehorses, the Tanhoughten's yacht, Renoir's 'latest film'—and it would all end with something like: 'Oh Darling, let's

have some Chopin. Let's have a cosy evening; let's be snug.' And she was thinking if only we'd bought Monet when first we married. If only we had two or three Munnings . . .

I wandered round the ward. The sawdust delighted me in the way that the rims of beer mugs in pubs had when I was a boy. The spittle. Well at least it was honest. It came from a stomach perforated not by ulcers born across a business man's desk, but by shit-hot work, humiliation, deprivation and suffering.

Darling, let's have Chopin's 'Champagne Polka'.
Delightful, charming, yes let's.

The ward was empty except for ten men. The remainder, about fifty-five of them, had gone off to make the top ends of fountain pens which would be used for, for what? They just had to put in the piff part, slot it to the right, push, pick up the blue end and punch it. That's why most of them were in this hospital—years of such toil. H. G. Wells, Huxley, George Orwell—they had all known about it thirty, forty years before. Chaplin had exposed it in the '20s and '30s, and everybody had laughed. Laughed like they did at 'The Great Dictator'. But the laughter had been as perfunctory as in a music hall act. It was the laughs which mattered. How few had perceived Chaplin's genius, comprehension and prophecy; his total understanding of man's inhumanity to man, his headlong flight into the obscurity of a mass produced, automized age which could, on a long conveyor belt, produce a million fountain pens per week, ten thousand car bodies per month. Ten billion nervous twitches and no one batted an eyelid. Chaplin, Orwell, Wells—Rembrandt in the seventeenth century, they had perceived the immensity of man's powers, his powers of

humiliation, torture and redemption through 'inner laughter'—laughter which was uplifting in the sense that Steinberg and Thurber in America understood it. Laughter which exorcised the soul through understanding its potentials, its immense powers for good allied to evil. Most churchmen tried to separate black from white. The impossible. I remembered two lectures which I had given. One had been on Steinberg, so little known or understood in England. The other on 'Contrary Relationships'.

The first had made my audience laugh, then realize, then perceive, then think, then pause . . . Steinberg explained! Like trying to show that Einstein equalled 'O' level mathematics. 'Contrary Relationships'. And many others I'd tried to deliver. Oh *what* was the use?

I had a long talk with a doctor three days after I was admitted to the ward. I had begun the practice, on the first afternoon, of keeping a diary using some sheets of paper clipped to a board. So that I was keenly aware of the dates, recording each entry with infinite care and precision. I had just written June 24 1964 and below it 11.5 a.m., when the Charge Nurse tapped me on the shoulder. I looked up and saw a pair of blue eyes with hard little cores in their centres. They did not appear to change as the mouth below them spoke; 'The Doctor would like a chat with you. Up in the office.'

I followed the tall bony nurse up the long ward. I noticed the dirty ruckles of the nurse's white coat wriggling round the shoulder blades and felt some of its irritation percolate into myself. The movements disturbed the peace which I had found in my room and which I shared with all the objects around the ward. The troubled streams vying between the shoulder blades contrasted terribly with the clean sweep of a window sill. I suddenly

hated the nurse and his boniness, his long stride and dirty white coat.

'Just wait here a moment,' the nurse said as he opened the door to the office, closing it quickly after he had entered. Thank God for that plain, brown door I thought. Its stain is an honest sienna. The brass door handle was comforting too; just the right degree of shinyness, calm and authoritative. The door opened again. The nurse beckoned me in.

A doctor sat at the desk. He pointed to a chair in front of it, slightly askew; 'Come and sit down and we'll have a bit of a talk.' I noticed the brown nicotine stains on the doctor's fingers. It was strange how other people's stains repelled me and yet my own were so fascinating. The doctor appeared almost as dirty, both in fingers and features, as the long, bony nurse.

'Do you smoke?' The doctor held out a packet of tipped cigarettes. There were only two left in it.

'Thank you so much—are they all you've got?'

'No, I've got plenty more.' Obviously not true I thought, but the act had compensated a little for the 'all else' which I so disliked in the doctor and nurse. The 'all else', their tiredness, their wrinkled coats, their unkempt hair, the dangling stethoscope so blatantly obscene, their finger nails, their passiveness, the sense that they were just passing the time and didn't care. The window ledges, the lockers, the blind cords—particularly the acorn nobs—these all 'cared', were responsible, tangible things, intent upon their work; detached from the flow of life and yet attached to matters of profound importance. The doctor was thumbing through a large index file. His jerky movements contrasted with the fanlike suggestion made by the pages as he flicked clumsily through them. I liked the thinness of the filing compartments, their neatness and pattern.

'Shan't keep you long,' the doctor said, not looking up. It did not matter to me how long I was kept. Even the irritations that the nurse and doctor had set up were fading away as I gazed at the squared window panes, passing through one, in the centre, to the flat expanse of a tree beyond. Everything inside this ward, I thought, is almost four dimensionally broad; all outside is neatly, tidily flat—a backcloth to an outdated play.

'Ah, here we are: I've found it at last.' The doctor looked up and attempted a smile; but it faded as swiftly as it had come. 'Now—let me ask you a few questions; then we'll have a chat.' The doctor picked up a ballpoint pen and wrote something on the sheet in front of him. The questions then followed. I was profoundly bored by all the answers I found myself giving. It was strange that a matter which concerned me so much—my sense of compassion—should bore me now to talk about. Perhaps it was that it was all in the past, right back upon the Playing Fields of Eton and a certain cobbled alley in which I had been bullied as a 'fukking yid'. Bullied by teenage boys who two or three years later were to win medals for relieving Auschwitz and Belsen! Perhaps because the terrible ordinariness of this little man, and his stained finger tips, stripped all meaning from past, present or future; perhaps because I *was* Anthony Rossiter, with a heart as warm as the soul of a ghetto, away from the chandeliers of convention; perhaps because I was just myself, alone and unafraid, in tune with the decaying objects and souls in the ward; their decay, their muted misted past, the true symbol of freedom—so entirely different from the muchi brown on the doctor's fingers, dead, and yet horribly alive, like excreta in a lavatory bowl. Suddenly I longed to flush out that imagined lavatory, cascade it with fermenting bubbles, marrying water and waste back to its primordial state. You couldn't

79

do that, I thought, to the doctor's finger-tips; they're etched to his miseries, and count out his nights and days in sienna shit. . . .

'Yes, quite, yes—I see . . .'

And so it continued for about half an hour. And when I left the room, the doctor rising from his chair, there was scored only in my mind the words, 'Count out your hours in nicotine stains, you unwise, pathetically ugly, mediocre, middle-aged and boring man.'

Chapter two

June cannoned into July as easily as two billiard balls meet and then part. July the neutral month, the green poised between full bloom and autumn decay. The month that makes no demands and pretends to have forgotten the past. Autumn is wise to the past I thought and wrote in my diary; 'June, the song of the moon; July the never started or ended month; waiting—without eyes—for the harvest, and the autumn which is wise'. I dated it July 25, and added below, 'I saw a crow. Black. It made the sky quite white.'

My sense of peace was disturbed a little, wobbled fractionally, one afternoon four days later. I had just finished writing in my diary. 'This matter of within and without, separated, is meaningless in that the within cannot exist without the without.' And I had done a careful structural drawing of two apples and a cup, investigating this inner-outer matter. I had sliced one of the apples to investigate its structure more thoroughly, and this dividing of the whole had reminded me of the problems

which had confronted Adam and Eve in the Garden of Eden. Perhaps had they shared it perfectly, sliced so that the upper part could be replaced on top of the lower, the confusion that supposedly follows us to this day, through their 'unbalanced' action, would have been avoided. Somehow I felt that even if Adam and Eve's greed had still made them digest the apples, the fusing, perhaps the next day, of the remains of the two opposing halves, in the garden soil of Eden, would have truly benefited future mankind. I knew, as I drew and wrote, that only 'marriage of forms', the linking of the golden chain, in whatever way it was achieved, could bring perfect harmony; and that mankind, at his peril, bit unevenly into any morsel which was created for the use of all. The part of me which relished the uneven fresh toothmarks in the serrated Adam's Apple, visually rejected practically the fact that the uneven gouges would never allow the apple to be restored to its entirety. Poor old Adam and Eve, I thought; if only they had had the opportunity to watch the opposing scales on a weighing machine vying with each other, before balancing, they would have surely realized the perfection, the only 'divine perfection', which is achieved through absolute harmony.

This inward sense of harmony and balance was fractionally knocked astray, as I looked up from my diary, and saw a tray of smashed crockery. It was close to me but I could not remember hearing it being broken; nor even the tray being set down. The shattered remains of a teacup, a badly cracked glass and a jug lying on its side was emphasized by the calm horizontality of the rim of the black tray on which the objects lay scattered. It was confusing to emerge from the tranquillity of a perfect Garden of Eden, a sliced apple and an eternal world weighed in harmony to this battlefield of destruction and violence. It troubled me for quite some minutes.

But as the sun moved down the window pane, towards evening, and rested for a while perfectly sliced by a window bar—making a London Transport Emblem upon it—my peace of mind was restored; I was able, without much effort, to return my gaze to the broken remains on the black tray—bringing a unity to the destruction, just as an artist harmonizes and reorganizes the unruly aspects in a landscape.

I shut myself in my room and leashed all my mental energies, through mind and eye, on the Linking of The Golden Chain. This was the title to the whole poem boiling with me. The first section was to be called 'The First Season, the Spring of Dawn and Evening' or 'From B.C. to A.D. through A.C.' This was based mainly upon the shapes of the alphabet composed within the square or circle; the similarity of a U to a V, their inversion—linking—and in particular the *totality* of a full circle or square, the golden circle of my dreams compressed to its most perfect shape. I include parts of this very hard and concentrated work, not because I think it a good poem (or a poem at all), but because the visual symbols and oral impact of the words suggested by them pressed as urgently in my mind for expression as objects have so often done in my painting. I wanted, beyond anything, to express once and for all the *need of unity*—the dire necessity of making wholes from halves and diamond stars from ecstatically converted V's. The facetious qualities within the more serious aspects of this piece of writing are an important and characteristic manifestation of the high flown swing of the pendulum.

The Golden Chain
The First Season, The Spring of Dawn and Evening

'Let's build a dam', said Eve to Adam,
'Honest to garden goodness yes,' said he
Not caring a fig in that omega of dawn
For Newton's laws had still to be observed,
From another apple eve much later,
And Adam, apple of her eye, soon to be—
Found Eve's figure, more rounded in the centre
To the Roman's count of ten, in that arena
But spelt of course E five to E, alone, that moment *V*
Appealing to the lion within him, tempting his apple
 pealing
With no red tape of bra bearing her bosom's breasts
In such quintessent balance, five to five, on early eve

(The poem continued for several pages upon the rela-
tionship of 'five to five' and 'V to V'; then it moved into
the exploration of the letter X and the upright cross.)

I say; more crosses known in asylums than I can cry
In these few words, whose bars of music matter to my
 ears and heart.
To more than any words of mine can tell—
For all are bared when barred from sharing You;
Alone, in some asylum, prison cell, there often is
No more than a few bars to an otherwise blank
 window—
Blank, that is, if you are blind to a blanket wall,
Expressed more solidly through the emphasis of bars—
Whose crosses etch each ego into cell much more
And more in cell, is not then found, for a cell confined
To such unbroken barriers frames its own.
Making the one of many into one of one, the

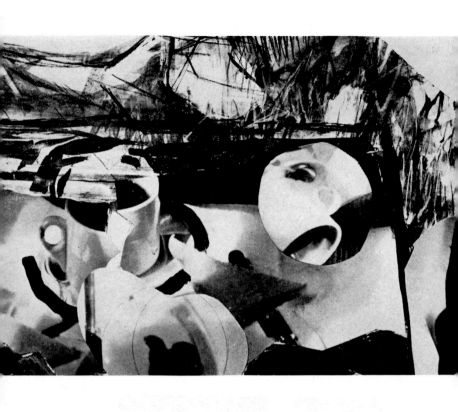

REMAINS, THE BROKEN TEA TRAY (see p. 82)

Left Sketch of a nurse, made under omnaponscopolamine (see p. 140)
Right ANNEKA ADJUSTING HER STOCKINGS, AS A NURSE, IN 1958
(see p. 135)

One of M—not Mercy, Merry—Marry,
But Mary of Her Sorrows, the murder of a son mindful
 in her I's,
Whose dripping tears are the ones of I—making the U
 and U and U
Much more than possible, a certainty if the tears are
Crossed in love, by faith that bars the bars from bearing
In to any soul confined from the compassion of a
 conscience
Clear of barrier bars of bearing in
But bearing breasts without to suckle deep within.

(After this outpouring of pain and suffering, I moved
into the concept of unity and quaternity—and then on to
myself—the universe in miniature.)

But I, like you, need in any composition—
As much in ourselves as in our homes—
If they're to be Ideal, the o and y to u—
—The right way round, at least in this part of Somer-
 set—
I do care a jot, definitely more than an iota—
For those at other poles, whose homes may be of ice—
Or Wams of Wigs—just huts—but who still must
 build—
Their own right homes, their way round.

(The poem then investigated fire, the speed of sound
and 'that dreadful form of fire'—the atomic bomb—and
ends with images of the sea through the letter C of the
alphabet.)

The theme alternating not by a jot, the only current
Thoughts which man that we have known and not yet
 met?

Perhaps face to face, being so far back and back—
The only laws of nature's selves the ABC to D of selves,
And other selves, born from cells (not potentially prison ones)
Which lead more happily the alphabet of whole from A to Z—
The alpha to the omega of the only permanent law—
Through two most capital of C's front to front,
(A passage to India is not always smooth)—
More seas have told of this, the rough waves to the smooth—
Through countless years of smoothing stones to round,
Through the pressing of its wrinkled furrows, down and in and out and back—
To confront the end in a seam turned round—still smoother—yet
Once more back to sea from land.

I passed from this outpouring of emotion in July to early August—to the hint of harvesting and visions of later golden days.

Chapter three

August, the month that moves us to the balding season of joyous sorrows. Movement, change—'you've had your time; time gentlemen please.'

By the end of the month, I had been allowed to visit the town with a few of the other trusted patients. I could have chosen to do so before; but I wanted no privileges; I had made that clear from the start; and since 'Old Alf'— deaf in one ear, and blind in the opposing eye, had not been allowed out to the town until his third month in the ward, I refused this liberty to myself.

Once out in the town, fresh sensations of peace and grandeur entered my soul, linked to those in the long ward; but they were different in kind, not degree.

It was a Sunday. A group of us had been invited by a charitable authority connected with the entertainment world to attend an afternoon performance of a new film, a musical adaption to a famous novel. As we shambled in pairs, similar in pattern to schoolboys' crocodiles but so different in our movements, along the almost deserted

Sunday streets, I was struck by the kind of difference which this particular peace brought to my being. Inside the ward, like night time, it was a world of two dimensions, the two dimensions of the soul which leads to quaternal questing. Here in the street, everything was blatantly obvious and three dimensional, proved, as it were, for a certainty. Nothing, I thought, is as certain as those dummy figures in that tailor's shop, so finite, so entirely sure of itself. But by half-closing my eyes, shuttering them against this illusionary certainty, I was able to drift back to the two dimensions which opened to the 'quaternity of all' and which once entered led on to a quintessimal point of inner knowingness that was as exquisite as a needle's eyes. I, the fine white strand of cotton, threading neatly through into another world, whose magic was assured once through this gate. I, the black thread, turning the fine periphery of the eye to a lighter key . . .

The whole of that Sunday was a period of suspended time. Suspension, a bridge of time, held permanently above a misted valley. The film, despite its lyrical and tempestuous pace, seemed merely to flicker like the silent ones of olden days, passing from one mood to another without real effort. Blacks and whites married by greys, shafts of brightness stilled by expanses of eternity. The end to the film had left a momentary gap, before the lights went up; and then, the cinema ill lit, had fused itself to the clustered figures in the balcony picking them out, without emphasis, not one by one but as a whole. The crumpled figures, trousers smeared with chocolate stains and tobacco wisps, rose unsteadily like flickering, gutted candles and wended their ways past unrelenting balcony seats, stuttering their way to the brighter foyer. Once there, with the summer afternoon more closely represented by shadows caressing breasts and faces, lips and

legs, we stood in groups looking lustfully this way and that, staring at those symbols of eternal youth and sex; but our lust was lost in the vacuum of time which engulfed the groups as a sculptor's cast holds in its grip the soul of the clay. Us, the clay of life, withheld from it by the cloister of a cast created by dots of dust, murmurs of cars far far away and time which had no reason to pass. Shiftily we looked to left and right, in front—then jerkily behind—dug in dishevelled dirty pockets, blew noses on crackly creased handkerchiefs and, on occasion, spat into ashtrays. One man fiddled with his flies, staring at the Sex Kitten framed in gold until a nurse rapped him on the shoulder and brought him sharply to heel. He exchanged a wistful look at the alluring Kitten for a frightened frown, thrust his hands defiantly deep into his pockets and withdrew them quickly again leaving them dangling at his side like a ventriloquist's doll when the act is done.

I watched all this in silence wondering at it all, feeling the cool shafts of air breeze in as the doors swung open, knowing that the speckles of summer dust which shimmered in the air were the daylight symbols to the eternal stars of night. Light married to dark. . . .

Back in the ward, I wrote on my pad; 'An object can be a subject and conversely a subject can be an object. It is the necessary paradox of life which Rembrandt explained so profoundly in the chiaroscuro of his painting. The lights and darks, his heavens and his hells, the chiaroscuro the sum total of his knowledge of within and without turned into divine reason. One can say no more, face to face with life and death.'

About a month later I and a group of patients visited the town again. It was September, siennaring to gold. The bus swept past stripped cornfields which had so recently been swaying, tormented and tempting. Now their twisting ecstatic songs had been cut down to minute perspectival

pylons stretching away to eternity, still and sad and motionless. Echoes only in colour of their former life and glory. Frozen memories of youth, just as are the stubbles on a face shorn of its beard. Reminders of life in death, whiskers grown on a dead man's face. Their infinite sense of peace, and minute grandeur, their stillness and lack of complaint reminded me of 'acceptance' as recognized by the Roman Catholic Faith. Penitentially shorn, aescetic and authoritative. Glistening under the September sun they sang in treble voice linked somewhere to a deeper bass. The smiling sun lit them row by row as they made no attempt to file down the eternal aisle.

A recently ploughed field, its furrows leaning diagonally one upon the other, was roof tiling the soul of the field for winter warmth, guarding it for fresh life again when the snow had passed away, protecting it from all that would assail its inhabitants without its care. Then in early spring, with the profoundest impertinence, would shoot up slim streaks of green, slender shoulder to slender shoulder, until there was a mass of green again. . . .

'The peace which passeth all understanding.' I had found it in the hospital. Here I was, lazing placidly under its palm tree embalmment, as cool as a Corinthian column. The nobility of this structure entered my soul and everywhere I saw echoed this placated, permanent peace; in radiators, wooden shelves, frames of windows, billiard cues and ledges were reflected this non-passage of time. 'Placated Eternity', I wrote on a bare piece of paper placing it perfectly right in the centre.

The world was a red billiard ball, the white and blacks eternal partners in marriage, their offspring the other numerously coloured spheres which danced off each other like folk at a May Day Dance. A world of limitless charity,

fusion, no fears. This, I thought, is how I've always known it *could* and *would* be; life not a dance towards death but death a dance to another form of life. I counted my days in the click of billiard balls. A progress of sound making marks linking the hours to the days and the days to the weeks.

My sense of peace, and increasing power, was entirely a matter of non action myself. I, the May Day Pole, around which the flow of life revolved. Pole permanent, poles apart, I and the balls, I and the crowd. And yet linked by coloured streamers blown by the wind where power touched all but myself. 'Non Action Myself' I wrote carefully below 'Placated Eternity'. Then, neatly above it, I added; 'Myself as a Pole'. Then, above that, 'Myself as a Whole'.

Outside the ward window Green June had cannoned into mauve July. July had quavered close to September and before I looked again at the calendar, sienna September had collided with orange October.

Patches of ochre and orange, and golden sienna, teased the tired green of the grasses and the weatherworn leaves of trees. Moments of glory exclaimed, of a sudden, from tips of branches to bases of bushes. Dried grasses burnt crisply and whitely, stately in their autumnal ease.

Inside the ward the crockery sang brighter against the darkening panes; the whole world was aglow with the soul of autumn siennaring to gold tips of cigarettes and trees. Rough acres bathed in glory; gardens, paths, wheelbarrows and benches burnt in pure delight and echoed their warmth back into the ward via counterpanes, moments of peremptory light, glasses caught by sun and cloths and patterned exquisitely in shadow.

Late October, bespectacled and balding, reminding of crumpled clothes, shaggy tweeds, briar pipes deeply lit, furrows in a field; how clearly, I thought, this month

spoke through Thoreau: 'Beware of all enterprises that demand new clothes.' With what honest candour nature shed its clothes, revelling in the new-found freedom of constructional boughs, blue hazy mists fogged like the wise watering eyes of wisdomed age. The complicated leaves of summer's glory, demanding to the unselective eye a mass of detail, gave way to the skeletal simplification of the trees which spoke of a permanence and peace which could not pass, bringing with it that profound sadness which a knowledge of eternity must inevitably bring— where yesterday, this day and the morrow are married in a solestial solitude. 'A Grandeur Beyond All Comprehension' I wrote in my diary; and below it I added, 'I saw a cataclysmic cluster of catonyastas, robin red—today— which matched the setting sun. My God, My God, how could my heart be so sad?' Was it Chaucer who had said— (said, not written I thought)—'Amor vincit omnia' Amour. Love conquers all.

It was growing dark. Late, late October. The ward was very still, except for the bent concentrated figures around the billiard table. The crisp click of balls—their finality— quieted my emotions down. I must not hate. I must only love, like those kissing balls, which met and parted free of carnal love.

I wrote in my diary, late that night: 'If I have spent all my hate, there is then good change for love.' And looking up I saw the night nurse by my bed.

'Your tablets Mr. Rossiter.' I extended my hand, opening the palm fully wide. The two round tablets sat quietly there. There was a long pause.

'Would you like a glass of water?'

I did not answer; instead I moved my hand slowly to my mouth and dropped in the pills, posting them to eternity.

'I don't know if Mr. Backhouse told you, sir, but you're

moving to a new ward tomorrow. It's called "Foster". They'll tell you more about it tomorrow. Goodnight sir.'

'Goodnight,' I heard myself say. 'Goodnight.'

I opened up my diary when the nurse had gone and wrote again, but in capitals this time:

'IF I HAVE SPENT ALL MY HATE

THERE IS THEN CHANCE OF GOOD CHANGE FOR LOVE.'

I had inserted the word CHANCE, knowing that as yet I was not fully redeemed and that the consolation of my compassion was still required—as from tomorrow in 'Foster' Ward.

I slept eight hours without a break.

Chapter four

It was that illumined white gate, leading to the hospital games field, on that late December evening which was the signal to start work again. The ecstasy of that moment, bursting from everywhere, prompted me to make haste back to my work; to continue my exploration into 'The Genetics of Divine Truth'; to explain the praises which the discovery of eternal truth demanded.

On this particular evening there was an empty car parked by the gate. Its abrupt stillness was accentuated by the bars of white horizontality which shot from behind it, to left and right. It jolted me to a halt; right back to that evening, five years before, when I had been driving home after a party the whisky rising in my head; a woman with two children timidly crossing the road ahead; my instinct, whisky accelerated, to force them back to the roadside's edge; but just as I put down my foot upon the accelerator a frightful image whip cracked into my head.

The naked Belsen women, running round in circles, hands above their heads with jeering Guards around

them. Cigarettes diagonally drooling from their hissing lips. I thrust my foot hard down upon the brake; my forehead linked to the thick pane, my conscience clearer.

The haven of those horizontal white bars, open armed in freedom—lit by the evening sun—was suddenly eclipsed by a steel grey cloud. Its sublime confidence was gone. It appeared remotely sad, forlorn—grey now against the white of snow laid at its feet. The sky, no longer light transformed the slim rectangles between the bars into dark shapes which accentuated the cross formations of its construction. Tight crosses in a line. Arms extended out and up, horror wise. You do not need blood for a crucifixion, I thought, just crucifixioned fences, tight tormented in their suffering. I walked on in a more sober frame of mind pondering in my mind the matters which I and Father Aelred had so recently discussed; matters that I felt it my responsibility to explain to the world at large. I could not blot out, from my mind, the stained image of that gate. It had spoken positively to me of so many matters, all linked by an extraordinary thread, just as the gate had been joined to its brother posts by blue streaks of wire. I remembered two other gates, in particular; one, a dark handsome iron construction, in the beautiful garden at Queen Mary's Hospital, Roehampton —close to where I so often wrote, whilst a patient there recovering from leg operations. Struggling, in so many ways; often self-pitying, cursing something which seemed to be eluding me. I remembered the beautiful, quiet voice of Christopher Devlin, my uncle's brother, a Priest of the Jesuit Order, his peace, his contentment and the shadows of the gate which walked down the stone steps on to the lawn. I had so often sat near those strong, clear strips of shadow. Was it only now, for the first time, that I realized that gates possessed a distinct duality? A duality leading to a trinity.

95

The other gate, a white wooden one, fifteen feet or so from the front parlour of a cottage I'd rented many years before, spoke to me now of three important matters. It had been a symbol of security, my barrier against a potentially hostile outer world. It reminded me that my barrier was another man's misfortune, a gate closed against the mentally unwell or the convict claustrophobically enclosed in a living tomb. And then there was the welcome that any gate so readily gave, swinging joyfully open at the mere touch of a finger. I remembered walking out of that cottage door, on a bright Sunday morning, the sun high and yellow and gloriously confident in the sky. It had shone straight into my eyes; looking down upon the red brick path, the seal of many winters blue stained upon its rough and friendly surface, seven bars of shadow had raced towards me—lapping at my shoes, sneaking up my trousers as I advanced. I had been setting forth, not as I imagined into a glorious summer day, but into a potentially prisoned world whose bars were branding me with just the stripes which had filled the concentration camps of Europe—not so long before. Immediately Robert Frost's wise and beautiful poem had come to mind— 'something there is that doesn't love a wall'. How right, how very right he was. And that went for all gates too. As I flung the gate wide open, not only were the concentrated stripes withdrawn from the russet path, but the golden expansive flaming ball—which can spin over any wall or gate that man can build—seemed to wink back and cry, 'you're right, you're right—fling open all the gates. Something there is that doesn't love a gate.'

I had been filled with the full glory of love in that new found freedom on that sunny Sunday morn, hedgerows and ditches, flickering leaves, bayonets of grass guarding fierce dandelions of fire and gleaming pebbles fusing them-

selves into positive forces bursting for recognition as do the early buds of spring.

The Gate. That gate. The Roehampton one. This December one, turned in an instant from a smiling face to one of torture, twinged into russet hints of rust, hinged in resignation for its task—all these were etched within me now speaking of matters which I must express. There was no Golden Gate in Heaven, I thought, no such vulgar materially wrought iron gate glistening 'up there'. Man had attempted, with this image, to take into the next life his material goods just as the Egyptians had taken their share of worldly glories to insure a safe and luxurious passage from the past into the future. If there needs be a gate, I thought, and God forbid there does, let it be a simple white wooden one, just three feet in height with a black easy latch and a hint of rust upon the hinges. Again I saw that cottage gate. The seven vertical laths singing white against the dark green verge and glorying in their stance; welcome for any stranger who might stroll to knock upon the door.

Signs and symbols were strewn everywhere, the upsurge spirit of the gates echoed in the stems of trees, the song of rusted hinges, reflected now in a hundred tiles, piled neatly in three rows, like rich furrows of a ploughed autumn field.

I remembered all this most solemnly as I swiftly walked along the snow laid road—marked with man's invented wheels, gouged in dark and purposeful emphasis, guiding me home as a mother leads her child by the hand in the first days of youth. It was growing dark. The day was almost past. Light gleamed from ward windows, a larger spray swept out from the recreation hall, embracing the virgin snow up a little from the road. Figures, dark against the doorway light, moved slowly, as if keeping time with the quietness of the evening world.

A world of darkness punctuated by lights, stretches of plain snow and pockmarked traces of man's daylight struggles and endeavours. My triumphs were reflected in those gleaming lights, my hopes echoed too, and in the snow laid footmarks traces of my sorrows. The two signs complemented each other as the shadows do the light, each essential to each other; there seemed, at that moment, no more strife—for a pool of light illumined the ridges of those dark etchings in the snow and there was marriage, true unison of black and white. The very essence which man, at his best, strove so hard to marry throughout his life.

I came abreast of another deserted car, with a window open. I stopped and clambered in. The steering wheel hard and round and firm under my hands. It was a link, in a cool dark lustred way, with the horns of cows shaded in the evening fields. Those horns, too, were firm and bold bracketing the magenta sky with the same assurance which the perfect circle enclosed the depths below my knees. A new moon horn appeared to my left frozen to the sky as the crescent white is smudged above a finger quick, not pointing, as a finger might, but waiting patiently for that perfect monthly circle, the pale full edition of that black peripheral wheel.

The link was everywhere. The horn, the wheel, the moon, the crescent curves . . . created, over a hundred years ago, in Bath stone just ten miles across those blanket fields. And there it was again, written upon the sky, upon my finger nails and echoed in bovine brackets so close by, and ridges shaped like prows of Viking ships setting sail for distant lands, ships bow linked to the bow of a circle musically acclaimed in gracefully bending trees. The conductor in his swallow tails, bow tying violin to bow in crescent movements. The link was everywhere.

The morning, dawning, of Christmas Eve. The Eve of Christmas come to cleanse old Adam's apple. I turned on my side in the bed and faced my locker, crammed with books. We all meet, I thought, upon the shelf of time. I stretched out my arm and took out a dark blue book; the *Poetical Works of Thomas Traherne*. By the faint light of dawn I read the inscription inside the cover. 'To Anthony, from your, if not at this time amusing friend, at least your companion in the muses—Roger.'

Roger, who had jumped off a high bridge in Kenya, a few days after sending me this book. They had never found his body. Roger, who had tried everything from tea planting, to hospital work, writing and three marriages; a leper colony and then that lone, high bridge. At noon it had been. An old African had seen him. Roger, whose laughter had so often seemed to set the world aglow; whose sharp wit was never raised in anger or to humiliate. Roger who had written to Father Peter, a few weeks before that jump, a letter so lovely and hilarious that it was the epitaph which he and I chose to remember. Father Peter had shown me that letter, which ended, 'A few years ago I suggested that the inscription upon my tombstone should perhaps be HE WAS ALWAYS TRYING. Now that I am so happy in 'darkest Africa' and, having tried so many things and failed, and at last 'found myself' —I wonder if that inscription could be changed to HE TRIED EVERYONE, NO ONE MORE THAN HIMSELF. Promoted into Greek of course: Eric Gill AVEC serif!'

Then a few weeks later . . .

He had never tried the river before I thought. My God what Golgothic hours those must have been . . .

I opened the book of poems at random. Traherne's *Fullness*, the second half. As I read the words they changed in my mind to:

It is in my power
Where all the amour lies
The fragrance of this hour
No kiss, my sacrifice
A little spark
That glowing in the dark
Ignites my soul to rise—
Cardinal to a Pope, a golden chain
Whose end, beginnings are the same
Unfastened to my bosom
 Buddha.
It is alone
That I do sit
A beginning benefit
That being made from chamber throne
 Both prove
The Golden Chain of Link and Love.

Carefully I closed the book and laid it on top of my locker. I lay back on my pillows and gazed out of the ward window, watching the dawn, tone by tone, wiping the film of night from the panes; I lay like this until the night's eclipse had become an apocalypse of splendour, the window bars a transport link accentuating, in their stillness, the ascension of the vermilion sphere into the golden stripes of heaven. The Eve of All mornings.

Sitting in the lounge, the afternoon of Christmas Eve, I noticed a small, richly coloured cigar box lying discarded on a table. I picked it up. Henri Winterman's. The richness of the box, vying with the wording, matched the duality of this festive season. A Winter Man, A Snowman set, with a cigar in mouth, diagonally top-hatted broadly challenging the apocalyptic season. The inner/outer man made to outmeasure the immeasurable day to come. I

carefully put the treasure in my pocket and went to ask for a nurse's permission for a walk.

Permission granted, if with another patient, the two of us sauntered out into the December afternoon neither of us speaking to the other. The silence between us was in accord with the stillness of the frosty scene. A row of ancient barrows stepped in silence to an iron sky of grey. I remembered them earlier on that day, when the sun had washed away the silence, to reveal dark strips of steps rising to an ethereally blue sky. Their horizontal assurance rising, step by step, had given them great heart. It had been in accord with the triumph of this season.

Now, as the afternoon paled down, the frosty mist silenced those assured strips of steps and another form of eternity was placed before them. Death, in the morning sunlight, lying deep down those barrows, had been assuaged by the contrast of light and shadow. This afternoon, death was fossilized in quiet fluted greys and whites of different splendour, re-echoed in darker hues of sky.

'Death hath no domination over me,' I thought, 'Death where is thy sting?'

'Death where is thy sting?' I thought as I floated out even further into the December afternoon, 'where *is* thy sting?'

We were passing the hospital cemetery, so symmetrically laid out that it seemed to prove, once and for all, that death was the equation of negation. Suddenly I noticed some flowers, sacrosanctly, humbly jugged, before a tombstone irregular from the others. The illumination of those frozen chrysanthemums, this unfrozen moment, drew me to the stone. Upon it I saw inscribed, not very well, 'Your Life Was Not In Vain'. The words spun in my mind, circulating out their inner truth, converting the message to, 'Your Life is not only in the veins, but

in the arterial flow of death whose fountain is the every spring born from each decaying year.'

Bending over the small jug of flowers, I noticed the wire inside which held the stalks in place. My thoughts went far back to another wintery afternoon when a very close friend, two years older than myself, had taken his first post in the Civil Service. Bernard, who had married Emma Strauss, and been the first member of his family to break away from their working-class world. His pride in becoming a Civil Servant.

I remembered more than the shine in his eyes when he had eagerly invited me to come to the Council Building. 'It's not really allowed,' he'd said, 'but you can be sort of looking for someone. Then I'll show you where I work.'

The first thing that I had noticed, in that large ex-pressionless room, filled with chairs and desks to match, punctuated by telephones and voluminous files, was the wire basket on Bernard's desk. The pile of papers within it spoke to me of intimate non-relationships, niceties tucked away for convenience; the wire frames of the basket were vent holes for the intimate and important matters, the hearts of the matters, which had leaked through them into the open room and become lost in the undisguised apathy of the whole building. Intimate non-relationships.

The sadness which I had felt, contrasting the vacuity of the room, the leaking baskets and the endless dispirited corridors with Bernard's enthusiasm had quite overcome me. I had not known what to say.

'It's nice, isn't it?' Bernard had said at last. Not a question. A fill in for the leaking basket.

'It's marvellous,' I had answered. 'Really tip top.' God, how I hated myself for those five words which were allied to thoughts of my studio, writing room—in which the totality of the room and the objects within it lent it

an air of contemplation and life. My working room which metaphorically, and therefore literally, was furnished with so much of 'my past'.

Looking down at the graven flowers, on this particular Christmas Eve, I realized that a metaphor was as literal as reality itself; in fact, I thought, more real being a picture word truth that far outshone the so-called reality. My dictionary always cites 'Glaring Error' under metaphors. If an error is an error, it could not be hidden away under 'mistake' or 'wrong choice'—but must stand the honesty of the sunlight search for truth amongst the shadows which complemented it; and 'Glaring Error' was as near truth as mere words could get.

Walking away from the graveyard, my companion some hundred yards ahead, my mind roamed round this matter of inner and outer, light and dark, truth and untruthfulness. Rembrandt, Van Gogh, Life and death . . .

I caught up my companion and we walked towards a small gardener's hut. A paraffin fire burnt inside it, and being empty, we sat down to warm ourselves.

'Ah that's good,' said my companion. 'I like a nice warm fire.' The first words he had spoken for quite some time; and leaning forward, his overcoat lapping the wooden floor, he extended his thin arms towards the flame. I was deeply moved by this sudden expression of rekindled hope, from this barren broken man, the thinness of his arms accentuated by the large, clumsy cuffs of his dark overcoat, and the humility of the simple gesture— a broken man bending towards a flame. A drawing of Van Gogh's came sharply to mind. Some paintings of mine from the past in which I'd used objects, faces, people, landscapes for the amazing variety of experiences to which they had subjected me. An object can be a subject and conversely, I thought, a subject can be an object. It is the necessary paradox of life. In great art the

two are inseparable, the one lost in the other. Who can say whether Shakespeare or Rembrandt are objective or subjective artists?

I remembered a letter I'd received from Peter Alford, my friend and bookseller, in which was a quotation—whose I could not recall—which ran: 'In anything, at all, perfection is attained *not* when there is nothing left to add—but when there is nothing left to take away.'* How true of the mystic simplicity and reticence in Matisse's great work. Picasso's adage, how pertinent that was; 'Have you ever seen a Saint wearing a wrist watch?' No watch, no time to lose . . .

It just depended upon whether what was 'waste of time'—whether man chose peace or haste. Or both?

More haste, less speed . . .

The flame from the stove was burning higher. Now my companion seemed larger too. I leant back and took out my notebook. In it I wrote: 'Great art, on all fronts, which of course must encompass profound thought, merely puts all aspects of the inner/outer life for us to face: it does not preach or promise, nor draw dangerous conclusions; but because all is exposed for view—the shining iceberg and its submerged face—there are conclusions to be drawn which each person seeks, and finds, from within himself—drawing upon his own (and, if wise, on others) experience. Consequently the deeper his own experiences, the profounder will be the RESULT of the work of art.'

'Dammit a painting is merely oil, cloth and pigment; a book—mere words and pages bound into a three dimensional volume.'

'No painting or volume that I have known—has ever given a blood transfusion or nursed a sick child through the night.'

I looked up from my notebook. I noticed a light switch,

* Antoine de Saint-Exupéry, *Wind, Sand and Stars*.

the simple controller between darkness and light. I sat literally wrapped in thought, my overcoat less warming than the thought which flamed out like shook foil. I bent down and added a paragraph, in capitals, below the first entry.

'BUT THE VALUE OF A GREAT WORK OF ART, WHICH LIES IN THE PERFECT CONTROL OF ITS VOLUME, *HAS* FIRED MANY HEARTS AND MINDS TO MINISTER JUST THESE FUSIONS OF BLOOD, CELLS, NERVES, MINDS AND SOULS BACK TO THE RIGHT CONTROL AGAIN.'

It was growing dark. Night was tirelessly unifying the fragmented day—just, I thought, as the artist puts together a wide variety of memories for a particular purpose—which can only be purported, discerned, by such a blanketing of the day/night self—illumined, on occasions, by the stars.

I leant forward once more and added in my notebook. 'Art is life. The sum total of life—which is only one form of reality, is the world.' Below I formed an equation.

ART = LIFE
LIFE = REALITY
REALITY = LIFE AND DEATH
LIFE + DEATH = THE SUM TOTAL OF THE REALITY OF THE
 WORLD WE KNOW
KNOWLEDGE = THE UNKNOWN, REALISED THROUGH
 REASON
REASON = THE DEVIL OR DIVINE.

As we walked out into the darkening blue black evening, I thought, one takes one's choice between the devil and the deep blue sea . . .

Chapter five

It was early on Christmas morning when I woke up. Dawn had not commenced its enterprising form of yawning. The long ward was quietly lit by four pale bulbs stretching down the centre. My thoughts wandered round many subjects, objects, people, memories, stories and quotations. I lay on my back, quite still, trying to remember who had written, 'Beware of all enterprises that demand new clothes.' Was it Oscar Wilde or Goethe? What did it matter? Nevertheless, the loss of its author's name rankled in my mind so that I decided to expend my energy on examining this statement rather than the futile search for a name. What's in a name, I thought, other than the letters formed together which make that particular person recognizable, outwardly and simply, to a mass of people?

'Beware of all enterprises that demand new clothes.'

One could take it in so many ways. Most important was the lack of 'preaching'. Not—'don't buy a new suit or wear a dinner jacket', but rather 'just beware . . .'

Here I was lying half in my birthday suit; my pyjama trousers had somehow slipped off in the night. Was the injunction one which meant—'lie here in half your birthday suit and don't get dressed at 7 a.m.' Tempting of course. Would that be the road to saintdom or just apathy? Let's be fair, I thought, a man is no worse off for wearing tails and a top hat. Or better for that—for man maketh clothes. And if we weren't all born to wear the habit of a monk we could scarcely be expected to carry out their habits.

A monk in a top hat? A saint wearing a wrist watch? A nurse in riding breeches? A business tycoon in sackcloth bound with a girdle? A bathing belle in rough tweeds and brogues? A saint in pyjamas? Father Christmas in a plastic pixie hood?

Well they *were* all there in these fusions of surrealist dress in the glossy magazines, the shop windows and on television. Did it affect them or us or both? Were the Bear Skins of the Brigade of Guards any smoother than the long-haired enterprise of our vital youth?

Both—parted well—what otherwise was basically and exclusively the same. Do we picture facts as we picture dress and faces to ourselves? What is a person's dress but the only reality we can face? And if a face is a fact, where lies its factum factuality? Is a face, a dress, the 'right address' the model of reality? Reality as interpreted by Rembrandt.

Patients were stirring uneasily around the ward. A bird chirped through the window pane. Dawn was commencing its struggle against the night, preparing to develop the Christmas of all Christmasses . . .

The only stockings lying near my bed were a pair of worn out grey ones, holes in the heels, the amputated pair of heels in holes. No oranges could snuggle there weighed down with pleasure by parcelled presents which broke out

in criss-cross crackers tied in ribbons. Holes of wool, hole of wholes, worth not hole or wool? Woolworths. Charles at his club. 'My *dear* Anthony of course one can't expect a Guards' Officer to shop in Woolworths. My *dear*—one has one's standards to keep up—more so these days—don't you think, eh what.'

Was it to prevent the woollen heads of Guards' Officers from being more woolwortherized? Or merely an ancient wellworth custom?

More patients stirring. Crumpled shapes in blankets groaning.

Groans close in tone to those I'd heard on a recent television programme. The Warsaw Ghetto. Could that ever happen again, that seemingly impossible Dantéesque cum Kafka prophecy come true?

After that programme I'd sat in silence, like so many others; could any one of them ever—anyway for a week or two—laugh about anything again? The next moment an answer had come—quite simply. Two small nudging worries evaporated entirely. Whether I should wear my blue jeans or dark grey trousers—and cut my toenails today or tomorrow. The trivialities of so much of my life smote me Joblike on the head . . .

Breakfast, the clatter of plates, sausages and bacon. Just a slice of bread for me. Mass at 11 a.m.

The pattern of the ward took its usual shape, punctuated on occasion by a Christmassy remark from a nurse or patient. The whirr of the electric cleaner polishing the present floor with dizzying reminders of all the mornings cleansed before. Time and floor treated for the future via the present and the past.

Four patients joined me to go to Mass. Geraldine, Pauline, Bentall and Frank. A nurse accompanied us. Walking down the concrete road, the frozen kerb echoed the stillness of the day. The stillness, the peace which

passeth all understanding, which I understood as the climacteric closely linked to a true love affair. How often I'd expected this climax, through frenzied friction, to end more sensationally than this. How often I'd expected the Day of Awakening, the Christmas of all Christmasses, Easter Morn, to be heralded by Trumpeters bursting through the sky. Now as I walked, close to the ageing Bentall, I began to realize that the apocalypse of time was dependent upon the apocalypse of dying in which all self was lost in loving. The standing still, lying quiet, in state and stead of dying. The realization filled me with profound humility—and a different form of need to pass this message on. But how? How to Bentall, bowed and barely shaved, cowed by life and man's demands, bossed round by bosses until there was nothing left in him to boss? How to Pauline, the self-admitted prostitute, whose love and laughter—and crippled hard up mother—had contributed to a necessary earning—in which she attempted to marry her loving pleasure with sense of more than a proprietied responsibility? There was no patent to her private proprietary other self sold pleasures.

Mass in the small wooden hut. A little late. The genuflexing half-hawking, kneeling, awkward threading through bowed patients, scrapes of chains, views of distended goose-pimpled necks hung in frozen bowing. A later patient genuflexing flickering before the stately candles, which in shape echoed the pale set of wooden Gothic panels upon the altar. A candleflame, I thought, is arched up and back in praise, attempting to set alight the pattern of the Gothic arches. Man at his best in architecture has frozen flames to his three dimensional stone desire, building in rock what his heart constructs through fire.

Mostly standing now. Some still haltering, fumbling to a stance. Missals rustling, no more preciously than nurse's

aprons. The Christmas Mass, a mass of auburn hair before me, cascading to a neat starched collar sanctifying through its halo the life released from its prisonal circumscription. The whole achieved through link of starched hollowed reticence, pure Puritan purity, and the unbounded flowing auburn hair.

The whole made from a hole healing scar.

The offertory plate close by. A Platonically coppered whole. A whole copperplate? Plato's famous maxim flamed into mind; 'the Desire and Pursuit of the whole is called Love'.

If God was Love, as Father Aelred taught, Plato's demanding action linked to the whole was also God. God the Whole, the universe, the quaternity plus the fifth in action; the quintessent quaternity. All of us, mind, body, soul; man the universe in miniature. Meister Eckhart a miniature, or larger, minister? 'God can no more do without us than we can do without him.'

The whole, a circle, with its implicated centre.

A quaternity freed from an egocentrically enclosed point. The mass in action, jostling—points to points, in the overcrowded Undergrounds whose train of thoughts were infected by the pointless jumbling. The mass in action!

The service in the chapel running smoothly.

'Thou art my Son, the Lord's word came to me, I have so nearly forgotten thee. What means this turmoil among the stations? Why do the peoples cherish dreams of vanity? For Our Sakes a child is born, to our race a Son is given, whose shoulders will bear the jostle to London Tower via Aldgate East; and his name shall be at Angel Islington, printed on the Transport Sign whose tight sphere of splendour is burst asunder by the eternity of open line. Sing the Lord a new song, a song of delighted transport, at his wonders. Cantate Dominoes, God knows 'is num-

bers, can't 'e come a queer road? 'E can't 'ave faked it.'

'What does he say of angels, Islington and transport? He will have his angels be like trains, the servants of the people that wait upon man's passions freed, like the winds, from the flames of fire.'

'There is no corner of a foreign world that has not witnessed how Love, not Hate, can save; for God's sake, in Love's Honour, let all the earth keep a Bank Holiday free of commercial enterprise, for Love has given proof of its saving power, without account, vindicated its just dealings—if just to just—in ALL NATIONS see just the reward of a hallowed day, unhollowed, in which the dawn of hope is linked to more bread than hope; come all ye peoples of ALL NATIONS and adore the Love which binds the whole human race, freed from the yoke, with just an egg and three slices of bread per day.'

'A great blight has descended upon the earth; and was Mahatma Gandhi right that food is the only form in which God would *dare* appear to starving people? Not only the food of fear, but the fear of no food breeds hate; queer today who purchases Lux Magna from the superstore and in the evening sings Alleluja to a pillar salt with which there is no egg to eat, NON PANE; JUST PAIN! And no more bread, nor cash for any inn.'

'Thine art the ovens, thine the earth; author thou, of the world and all it publishes; right and justice are the pages of thy publications, the prices of thine Empire. Hallow the gifts we offer, Lord, Love-a-Lot, by the only begotten Son's new birth; and cleanse us wholly from our sins of allowing East or West to search in vain for food from dustbins.'

'Viderunt omnes fines terrae salutare Dei nostri and let all nostrils be free of stench.'

'Allelujah; and pass not any ammunition more, Oh Lord—between East and West.'

As we walked back from the chapel, the sun broke through, just for a moment, picking out with sharp precision the specially lovely trees and gates and walls. The pointed spire of St. Cuthbert's Church converted, in a flash, from dark to brilliant white—rushing to the sky.

'What is inspiration,' I thought, 'but the inscaped power of aspiration spiralled from within—lighting a spire without?'

As the sun withdrew its inspiration from the spire, so the day returned to grey—to graver matters matching Bentall's stooping shoulders and shuffling gait.

A word there—a word here, half heard; not more.

When we returned, the lounge was being specially prepared for the Christmas dinner. The square tables, which normally seated four, were being paired in a row to seat sixteen, eight each side and a place at either end for a member of staff. Two long tables were being formed this way to accommodate the thirty-two 'mixed up' patients. Sixteen men and sixteen women.

I stood at the side of the long lounge room watching the complacent squares of tables being converted into a long festive one. Four tables were just in the process of being gathered together to start the second one.

Four by four, four square, the sign on that round tobacco tin. The perfect square, the perfect circle.

So close.

Swivel a square round and round—lo and behold the circle. No wonder the younger generation had exchanged the portly circle for the square as a symbol of a bore. Too perfect by half? the circle too perfect by whole?

I imagined a bee fluttering overhead, eyeing the squares for hives; the mass cubed modern semi-detached residences converted into octagonal, occidentally, non-accidentally constructed homes for comfort, breeding and honey.

'And is there honey still for tea?'

Bees knew a thing or two about the taste of honey. The octagonal—half-way between man's cubic reality and the hemisphere. The hemisphere, not flat—nor even spherical; immeasurable in man-made terms without the aid of Einstein, relative to the non-existence of straight lines. How then a circle or a square? A triangle? A spire, a maze, a spiral?

An amazing picture, which made me laugh aloud, came into my mind—of a hive of happy, busy, buzzing bees spiralling around their Octagon in contrast to the busy bees around the Pentagon.

The Pentagon. The mystic number five. Vietnam alive? Where had we gone astray? Chips with everything and honey still for tea in all the supermarkets; penthouses drugged with stores. Penthouses supporting rooves of Pentecostal penury without.

Was it worse to be pent up or in—shut in or up?

Two patients cast a white cloth over the squares of tables, unlining their attempted fusion with its stretch of sandy ruckles. They pulled it tauter—so that the ruckles disappeared in a beach of white.

The table laid with crackers on. White and red, Christmas Dinner the same as the Last Supper. I, who had so often expected the three days' wonder of that fateful supper, the 'afters', to be the same dessert as the 'befores' of Christmas—now realized, as I sat down at the long laden table—that there is properly no biography, only history of the souls. Indeed the clock of centuries had proved man's suspicion when the Great God lets loose a thinker on this planet.

From Christmas cradle via crackers, Easter tomb, cracked egg, had been delivered a faith in the burden of a yoke, born within the cloistered confinement of the yolk. A joke? A fable? Mere allegory?

The dinner was well under way and many bellies and even more unbuttoned waistcoats. A glass of beer per man, cider for the 'girls', roast turkey with all the trimmings. Plump women, plum pudding, holly, brandy butter turned to saucy jokes from the sex starved simmering bantam banter.

I was sitting next to Morbidroff. Matron had just come in, uniformly green, tall and thin, hands clasped in front to cancel out her grin. The smile of benevolence born of twenty such Christmas feasts. A gold tooth to match a cracker label, a grey face in accord with the window panes.

'A happy Christmas to you all,' she said and grinned again to reveal more than a gap in her back teeth.

The ceremony as usual, matron pulling the first cracker with the senior doctor. Morbidroff, half standing, moustache smudged in sauce, fell nearly from the table with that pull. Some laughter; not much.

More patients pulling, pulling patients from the table. Masks and hats, clerihews studied closely for some clue.

The tragedy in many faces emphasized by the coloured hats which crowned the unsuspecting clowns.

The dinner over, most jokes spent—some went to spend a penny, others to the telly room.

I, still sitting at the table, heard Dr. Cutler, the hospital dentist, carrying on his half drunken monologue to Mrs. Heaven, the Welfare Officer. She listened patiently with her ears, her steady eyes watching for an excuse to leave. I joined them, sauntering up as Dr. Cutler was saying; 'the mansh's a menace—what's hish name—Graham?— Heart of the Matter—Green. Green Graham, Graham Green and all shat dentist business. Jusht tommy rot. Dash it the dentisht isn't socially inferior to the doctor.'

Morbidroff had joined us. Calm, moustache wiped free of sauce, square, bull shouldered, standing—his voice as controlled as his presence; 'I don't agree. Graham Greene

was only commenting upon a situation which is true, in our society, basically.'

'There's nothing bashic in our society,' fired back Cutler.

'Nothing basic? My dear man! Anyway I wasn't meaning that.'

'We're as good as you—any day!'

'I quite agree,' replied Morbidroff.

'That man's a fool . . .'

'I don't agree; he's certainly not a fool.' I interrupted, hesitating slightly; 'I wonder if the social status of a doctor, finally—in our society—doesn't rest upon his constant dealing with the ultimate—whilst a chiropodist or dentist deals merely with the extremities?'

'Are you comparing my profession to a chiropodist's?' His anger was intense. I was profoundly embarrassed; quickly I added: 'No, No, of course not, of course not . . .'

'But you did!' fired back Cutler.

Morbidroff quickly, tactfully intervened; 'What Mr. Rossiter means is that there are extremities more extremely important than the ultimate ones within.'

'He didn't shay that at all.'

'That's what he meant; isn't that right Anthony?'

I looked in amazement at my doctor, appreciating both the profundity of his remark and tact.

'Come now, Anthony, let's have a cup of coffee—perhaps a game of darts. Why don't you join us, Richard?'

'No thanks—but thanks all the same.' He gave a dirty laugh. 'I musht rejoin the Missus—I promised her a spechial Christmash afternoon.'

And so Morbidroff, the old black horse, alsatian dog—his arm about my shoulder—guided his patient to an empty armchair. Pulling up another, close to me, he relaxed back and began to chat.

Morbidroff lit his pipe using several matches before

the smoke began to rise. I dug in my pocket to follow suit and soon both of us were puffing the day to rest. Not much conversation whilst the pipes got burning . . .

The sun had at last come out.

The doctor looked up at it and said; 'Well, Anthony, how much longer do you want to stay in hospital?'

I didn't answer straight away; I drew slowly on my pipe.

'You do realize you can leave just when you like . . .'

'I know,' I said; a pause; 'I don't want to leave quite yet—not until I've solved the Golden Chain.'*

'I know all about that,' said the doctor kindly, 'surely that's in the past and finished now?'

'It's not quite as simple as all that,' I replied.

'Can you explain a little more?'

I leant forward earnestly; a sudden torrent of words poured forth, punctuated by pipe thrusts and movements of both arms and hands.

'The Golden Chain I used to wear across my waistcoat —the umbilical cord of Mayfair, binding us from right to right—an upturned rainbow with sacks of gold at either end—whose pursuit was never ending. An Astral watch one end, a golden key ring in the other pocket—the rainbow whose golden ends we could always find, allowing no more dreams . . .'

I paused, then carried on:

'The umbilical security of a cord and chain whose dazzling rings drawn tight across our bosoms locked us to the womb.'

'The womb of what?'

'A womb of bosoms portly packed with caviare and salmon—weaned with brandy, Scotch, champagne. Chameleons only in name, not feeding habits.'

* A psychological problem and novel upon which I was working at the time.

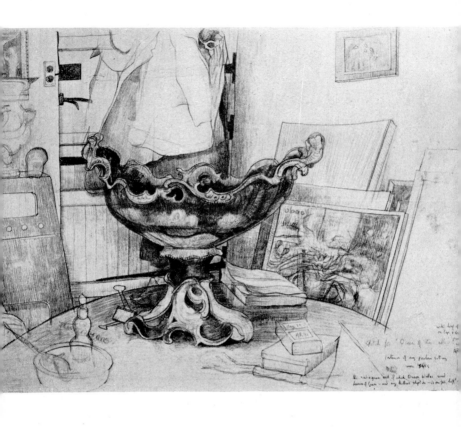

QUEEN OF THEM ALL (see p. 130)

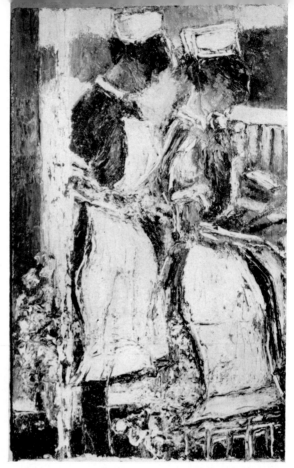

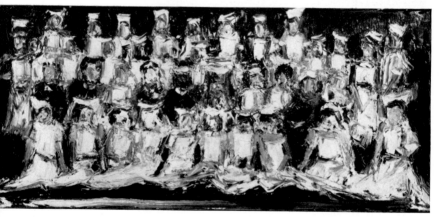

Above WORKING NIGHT NURSES AND SLEEPING PRIMROSES⎫
Below THE PRIZEGIVING ⎬ (see p. 143)⎭

'A Golden Chain, a silver spoon, an umbilical bloody cord—they're all the same—best broken. . . .'

The doctor leant forward to thrust in a word with the aid of his pipe stem. It was waved aside.

'Who said, "In a picture objects have the elements of the picture corresponding to them"? He's dead right!'

'What a picture we all made!' Hardly pausing, I continued on.

'Now if you look at nature, the chance arrangement of objects, almost always, is of a natural and unselfconscious appearance. When man imposes his order, the arrangement is inevitably stamped with some part of his self consciousness.'

'Nature, governed as it is almost entirely by functional requirements, takes its pattern from a practical cause of order. Stones cascaded from a broken wall form a continuous flow governed by the natural instincts and adaptabilities of each stone in relation to the whole. A large stone may well be hidden by less superior ones, the very weight of the heavier one having carried it to its death more speedily.

'Chance in nature, or objects arranged without formal consideration—obey rules that are impossible to set down. Or put another way, they obey the only rules which allow for existence, accepting the potentialities and limitations of a given moment and geographical situation.'

'It is in this light that we enjoy nature and learn from her—when (not surprisingly being natural)—she teaches us from practical and purposeful experience.'

'This same practical, natural quality often exists on the chance arrangement of man-made objects—which unify themselves by sheer necessity for survival—for the most comfortable and immediate means of repose; and with this repose comes harmony, for harmony is achieved by balance and balance by weighed considerations.'

'Man weighs his considerations with such conscious thought that, often, repose is lost to effect. It's the difference between prim suburban gardens and sprouting refuse dumps.'

'I find—on the whole—that when the plumber dumps his tool bag—and accessories upon the floor, they boast this unselfconscious unity—the chance arrangement being dictated, not for effect, but for practical and purposeful ends. These very limitations are the root of all . . .'

Here the doctor interrupted; 'Steady old man, calm down a bit—take it easy.'

'It's true.'

'Surely all you're saying is that beauty lies in the eye of the beholder?'

'Not in the eye, or I—it's strewn everywhere!'

'But surely only for the looking. . . .'

'In perception. . . .'

'But what *is* perception—surely? . . .,' the doctor, leaning forward now.

'Perception,' I paused, closing half my eyes and looking to the ceiling—my eyelashes the screen to inessentials, 'Perception is the power to grasp with both the mind and soul—call it heart—what the eye cannot always see. To see both the woods *and* trees together.'

'But you're still dependent upon the eye. . . .'

'How wrong you are! The eye is merely the lens potential to the view. No lens, you say, no view?'

'Now you're being clever.' The doctor relaxed back, leaning on his chair and profession; 'Now you're talking about "no eyes"—being blind . . .'

'That's not clever, it's merely fact in many cases. . . .'

'But if you're blind. . . .'

'You use your hearing doubly well,' I replied sharp as a knife.

'You can't "see" with your ears. . . .'

'Those who have heard aright have seen much more than those who have seen wrong—or not right at all. Beethoven didn't do too badly when he lost his "sight" which we call hearing.'

'Ah now I'm beginning to see. . . .'

'And hear. . . .'

'*And* think!' replied the doctor with a twinkle.

Our search for truth and beauty seemed to have taken something from the outside scene—both our minds unfrozen in the glow of a Christmas sun which did not disturb the still frosted garden. No word was spoken for quite some minutes. The doctor refilling pipe, both of us relaxed in pleasure. The flame from the match withered down, and there was black where so recently was red. The smoke was blue, a pale echo of the royal thoughts which ran through my mind.

The doctor spoke, his voice quite gentle—profound enquiry; 'What is it that you are trying to find—to tell? Something more than breaking with a golden chain, a bloody cord and past traditions?'

'Something of them all—for I'm not against tradition if that hard won "trade" of past is linked to the present trade and trend.'

'Pray continue, sir,' the doctor answered humbly, 'I'm profoundly interested.'

I leant forward in my chair and dug in my coat pocket. From it I withdrew my notebook. Leaning back, I opened the book and found the necessary page; looking up I said with simple dignity. 'It's written here; if you will bear with me, I'll read it for what it's worth. I've borrowed a bit from Willy Shakespeare,' I added with a smile.

With grave dignity, exquisitely controlled in power, I commenced to read my adaptation of one of Shakespeare's most famous sonnets.

Morbidroff sat quite still, the movement lay within his heart, which with a more emotive man might perhaps have reflected in his eyes. His eyes not wet with tears but lost in thought. He broke the silence, saying sadly:

'Alas there's not much I can do about that "something"—you have indeed better bettered expectation than you must expect of me to tell you how.'

'You love your Shakespeare too.' I smiled, asking: 'You don't think I've made much ado about nothing in that writing?'

'You have indeed better bettered expectation than you must expect of me to tell you how,' answered the doctor once again.

A pause. Both quiet and serious. At last the doctor asked: 'How would you, Anthony, set about making such a picture come about?' 'World Government?'

'Such a picture come about?' I was thinking out aloud. 'What was it Wittgenstein said—oh yes I have it—"What constitutes a picture is that its elements are related to one another in a determinate way".'

'Do you agree—I mean in painting?' the doctor humbly asked.

'I do indeed—but I see no difference, potentially in a picture or the world. Dammit what constitutes the world is that its elements are related to one another in a most determinate way—with man determined to walk the tight rope from pole to pole. My God—we're poles apart!'

'What Government or control do you think would work?'

'Control?' I paused; 'the dictionary may help us. Excuse me for a moment and I'll get one.' I soon returned carrying the large black book. 'Let's see what it says.'

I concentrated hard having found the page.

'Ah—here I have it. I would choose, for control, "standard of comparison, for checking inferences deduced from

experiment—true verification"—as opposed to "Power of direction as a means of restraint".' I closed the book.

'A world comparer?'

'We've enough compères.' I added laughingly, 'No, I would say a world . . .,' lost for the word, the doctor butted in:

'A world steward?'

I paused to think, looked up at the red winter sun and said, 'No I think a world steered by pilots.'

'That sounds mighty fine! Of course you mean pilots from all nations?'

'Indeed, universal pilots are what we need.'

'As opposed to the present pilots of the universe?' joked back the doctor.

'Past pilots too,' I added, 'Last came, and last did go, the pilot of the Galilean Lake, two massy keys he bore, of metals twain, the golden opes, the iron shuts again.'

'I must apologize—but who wrote that?'

'Milton—he knew a thing or two.'

'But as a Roman Catholic, Anthony . . .'

'I'm more Catholic these days than Roman . . .'

'Have you given up your faith?'

'No, I haven't lost my faith—lest it's wrested from me by the Vatican—I'm just less parochially minded than some of the flock—less Roman—perhaps more human....'

'A humanist?' The doctor really interested.

'No—I hate words prolonged in ist. No—a human being first—then a Catholic after that—and a Roman one far later still!'

'I take it you mean your late conversion?'

'Doctor—you're now being ingenuous—insidiously trying to pilot this conversation off its natural course—from control to faith; having taken such a risky compass perhaps you may note the buoy, the apparent of the sailor's letter as it were, which sometimes in a fog transparently

disguises the course of so many Catholic seamen; upon this often non-apparent maritime device of labour's anchoring—might well, I think, be clearly capped (not in Double Dutch but all other tongues) the words, lit of course for night; 'As there is, in starving countries, no control in death—why should there not be control in life?'

There followed an air of silence in whose dustless temperance the control of birth, birth control, free love, dear to dear close knit and webbed, based low to high—thrown back to forth in both our minds—attempting to thaw out more than a frozen way of deathly life—the doctor's thoughts pregnant with birth for more healthy life, mine replaying on my disc of memory a waxen image from a wireless talk I'd heard—in which was said life could be deep freezed, preserved, frozen in incurable sickness, until the frost of present knowledge had thawed out to the future streams of enterprise—with a cure; mankind, deeply frozen, scarcely panting—waiting endlessly for a new Medical Madonna, a profound Curie.

A patient walked, if *that* is the word for shambling through a room hand not in hand with Saint Vitus' Dance; the silence broken through the weird manœuvres of a man whose moderation, self control were hindered only by the lack of skill to understand, tranquillize this over lively death which led to no naturally speedy end.

John was his name, thus baptized; wet fingers dipped still in waters which run deeper than is still yet known to gently sprinkle out . . .

Sometimes the fountain overflows . . .

All his records showed that he had been as good, in all his life, as that good name, John, unwell, evangelizing now with the aid of Saint Vitus—from whom a few wished to learn, in fact most pitied, meat for many to exclaim—a host horrified even more unsanctified by the laughter of

the few who, unhysterically but loud, shouted 'lock that over vital host away!'

There are many such vitally important, uninvited guests skeletoned in cupboards—protecting more the pride of family than the bones of these unwanted prisoners.

John had passed, somehow, through the room. The clatter of his passage still wrestled in our consciences. Lost not for thoughts, but for words which could convey the vehicle of their worth.

I spoke, quite quietly, first.

'Attempt to control—that has been well illustrated in recent moments—what do you have to say?'

The doctor paused: 'Thoughts are the torturer of my soul which rises in anger at the worthlessness of words.'

'I so much agree,' I said quite simply.

The doctor, speaking quietly too, replied:

'A limp, lack of control, a dance to death, a scar, no arms, one leg, a bandage?' Here he paused; 'There is no moral to a bandage other than what it attempts to cover; like ourselves, a bandage can soon turn from white to dirt. Ask any nursing sister—which is best—a clean bandage or one that's soiled.'

'How right you are, dear doctor; you know my fondness for Van Gogh—more than just his work. Now take his "limp", his cross, his ear, his bandage; those who indulge their thoughts morbidly—Dear Morbidroff—pray forgive the play on words—they're from my heart—morbidly, unwittingly, upon that great bandaged ear that wasn't—removed without the soul of sanity voiced in his letters—they will only grasp by the ear what the soul releases in love freed from fear—which if they can read, and risk care uncanned to the world in those voluminous cornvoiced, uncorncracked, unstooked stems of golden wisdom—from which no ear of wheat is too small a grist

for any mill—then, only then, will their prejudice inclined to the need of mad scaffold drop in others to assuage their quenchless blood within—be banished, a bad dream, by the lust for life which raped his landscape clean—bringing the virgin dream to fire without (despite the cost within)—without which we can perish, all of us, poring over the Electric Chair, from the snugdom of our electric blankets, each Sunday morn—press guttered to our beds and bosoms.'

'The soul of sanity from the heart of Vincent guiding the mad death wish pulse of man through to another fall, another Eden, another bridge from which are seen more springs.'

God rest his soul in Arles and Heaven,
His tomb, near Paris, not Toulouse,
Low Trekked not in vain—to lose—too—
Pain dwarfed on this lonely trek.

From this windmill speech, a silence born, from the blades of Holland stopped in awe (a shortish trek, turn Paris)—and into both our minds stepped plains not damned yet lowlands stopped—dykes not in vain but stilled by rain, filled with pleasure stooping to spring tulips standing.

The silence all.

The sun still in the sky, the room still there.

The doctor leant a little forward: 'Anthony—I scarcely know what to say but I wonder,'—he paused, 'I wonder if with all this thought, and my God it's such by any other name, I wonder if you should not relax; why not do a crossword in the evenings—to relax?'

'Relax the what?' I queried.

'Relax your mind.'

'I have never, doctor, known a crossword to relieve a mind of anything but fear!'

124

'Then—are you not afraid?'

'Afraid of what?'

'Overtaxing your perceptive mind.'

'I would rather tax it at my expense than the *Sunday Times*!'

'We seem telegraphed together this fine Christmas afternoon! Rather telegraphed than telescoped!'

'Are they so different—really doctor?'

'How now brown Rossiter!'

'A telegraph? A telescope of time.'

'You ought to work for the match box companies!'

'And spill on the matches' coffins, the taper of my fire!' I laughed and lit my pipe again.

'Spell, I think, not Spill,' the doctor very pleased.

'If unlit matches, lit, freelit cast a spell, my light—as you know well—spill binds—with cost!'

'You have me beaten, dear Anthony, checked in mate—what can I suggest—a game of chess or tiddlywinks—if you won't allow a crossword!'

'My dear doctor—I'm not joking now—if words cross, they fence for freedom; and I'm against all parrying that entails crossed swords—or words.'

'Come let's have a game of chess—I'll check your mate before you've even dared date my Queen.'

Thus the devil played at chess with me, and yielding a pawn, thought to gain a queen of me, taking advantage of my honest endeavours.

Sir Thomas Browne

Part three

Something there is that doesn't love a wall,
That sends the frozen-ground-swell under it,
And spills the upper boulders in the sun;
And makes gaps even two can pass abreast.

Robert Frost

Chapter one

During my hospital sojourn I had been guarded by walls of a very different quality than the ones which surround our house in Litton. When I was allowed to leave hospital, these country walls danced their messages in my mind as vigorously as trees, shrubs, grasses and clouds. I needed them in one way and required them less in another. At first glance their rough and tumble order satisfied that part of me which is also balanced in that manner. But on closer inspection I found echoes of sufferings closely allied to those etched within me from the severe mental breakdown which I had recently experienced. One wall, in particular, haunted my imagination—a wall near our kitchen garden which was fast tumbling and disintegrating. Its schizophrenic collapse into two almost equal portions—bridged by one long stone which bound the disintegration together—constantly mocked and reminded me of the divisional world which I had so recently inhabited. From beneath the bridge stone—the upper jaw, a sienna tongue seemed to stretch itself out in the act of

devouring great morsels of stone. This ravenous cavern was surrounded on all sides by tufts of growth, giant bristles to a gigantic scene of almost obscene horror; it seemed that the largest rat in the world had been caught in the act of devouring the human race, its bristles declaiming its savage and relentless intent.

At other times it evoked an unsatisfied desire which increased the incubus and desolation within me to a point of purgatorial nightmare. Its tribulation and malaise were even more increased—insensed—by its dogged endurance. My whole wretchedness was totally symbolized by this schizophrenic seizure of a wall.

I tried to remember the wall—the long gentle low one—which lay behind the sandy beach from which we often bathed on our holiday the year before in Cornwall. Desperately I tried to recapture the feel of hair half dried from the salt water of the sea—gathered in a cluster beneath a coarse white towel—recalcitrant yet friendly. The same hair 'too dry' a few hours later, combed before the looking glass of our small room up at the farmhouse, thin and clean and perfect like the finest kind of wire—matching in quality the scrubbed and stained wooden floorboards which peeped from beneath the bedroom carpets around the room. And the 'sand-in-everything' which is so much part of a seaside holiday—so annoying and yet reassuring. It was the kind of reassurance that I most needed during those first few weeks at home.

Continuously, during that time, I searched my memory for other scenes and symbols of comfort and assurance which would fend off the fierce ones jostling for priority within my mind. I travelled back ten years to the time when I had been teaching art and several other subjects in a preparatory school in Berkshire; to the time when I bought my first cottage deep in the countryside. I remembered the rusted sienna gutter tilted from the horizontal

which I could just see if I lay back in my bath in the white painted brick bathroom. I remembered its link with me, one summer evening, its tuneful, purposeful brown contrasting against the solemn cool of the white bricks—echoing the upper half of my body which was deeply tanned by the sun—brazenly and sensuously contrasting itself with my thighs and legs which the sun had not converted from their paler tone. I remembered the delight when I stood up in the bath, of seeing this contrast even more strongly and the pleasure I received settling back in the bath and marrying the surface line of the water to the demarkation line around my body. Removing a sticky plaster from my forearm, I had marvelled at the perfect pale print mark and curve which had been revealed in the way that a photograph is developed. That shape linked itself to the past just as photographs do in a family album, nostalgic and precious in a particular kind of way, provoking strange and veiled memories. I had been reluctant to allow the healed wound its freedom from covering, reluctant to allow the white print to become stained by the summer sun. And the same part of me which did not want the eradicating of such a precious piece of the past, revelled sensuously in the almost indecent tan which the upper part of my body revealed. I wanted to eat my 'super brown tan' whilst I wanted to swallow the pale curved strip, as a gourmet enjoys an oyster.

I looked back at the past through my drawings, a drawer full of them evoking those three years in that old cottage perched at the top of a hill on the side of the Berkshire Downs. One in particular caught my attention, a pencil drawing done in my parlour sitting-room—entitled 'Queen of Them All'.

When I had returned home from hospital, despite an anthropomorphic link with nature, I had found myself estranged from the rooms which constitute our home; I

seemed to stand at a distance from the objects within those rooms, to have no part whatsoever in them. A faintly glazed partition of glass had slipped down separating my home and all that constituted it and myself. So that when I discovered the drawing of my parlour sitting-room in Berkshire, made ten years before, I was amazed at the lucidity of the objects that dwelt within it; and even at the distance of ten years—my connection with them all was as distinct as it had been at the time of making. I began to re-enter the reality of the world around me, in my west country home, through that pencil drawing.

I had named this drawing 'Queen of Them All' because of the majestic insistence of a beautiful blue and white porcelain fruit dish, which 'queened' itself over all the other objects within that musty, cottage parlour sitting-room. Its actual elegance and sophistication set it apart from the more mundane furniture and 'res' which filled the room. But I remembered well, as I had drawn it, how the sophisticated rococo curves of the porcelain dish had emphasized other lines and movements which constituted the more ordinary objects, insisting by her 'lead' that her 'subjects' too possessed qualities and perfections which complemented her own. This Queenly Dish had insisted that I note the taut, slightly smug, line of the brown wooden radiogram—tilting backwards with a hint of insolence upon which another rococo jug was standing. And that I take particular note of the halo curve formed by the small brown loaf of bread perched on its edge. I remembered the taut distinction of that peripheral line of bread which contrasted with the implied softness of the form within—a quality which challenged the porcelain dish whose peripheral lines knew not such a gentleness and were formed by an elegant severity of purpose. I had found this same severity of purpose echoed by the door fittings which guarded its interest and was re-confirmed

by their shiny blackness. The pile of coats hanging from this door had taken some of their line and melody from the small brown loaf of bread; they had insisted upon their informality time and again as I drew them—the proud 'country cousins' to the object which aristocratically dominated the small room. I had found the same qualities of 'worn-ness' and informality in many of the objects decorating the table—the ear-marked book, the curved clay pipe and the slightly bent pipe cleaners. The glass pot of glue, on the left of the table, had insisted on a little more pomp as I translated its form, firmly promulgating its important purpose in life—particularly in a room whose main concern lay in the writing of words and the making of pictures. 'Without me,' it seemed to say, 'you wouldn't be able, so easily, to put all those shapes and patterns together in permanent form.'

As I gazed, almost hypnotized by the past melody of this beloved room of mine, so the present house around me began again to unfold its particular sacristy and reality. Again I began to realize the import, for me, of being surrounded by objects which I love and treasure—arranged in patterns and groups which re-affirm my most important inner needs—both physically and spiritually. Objects which lived the same kind of inner/outer life which I did—and reflected the matters and qualities which I most treasure and honour in life. Objects and memories which fitted my wife and myself as a well-worn old coat fits its owner after many years of close companionship.

And thus I found myself wholly back in Litton, wholly restored to the world which my wife and I had woven together over seven complex years of married life.

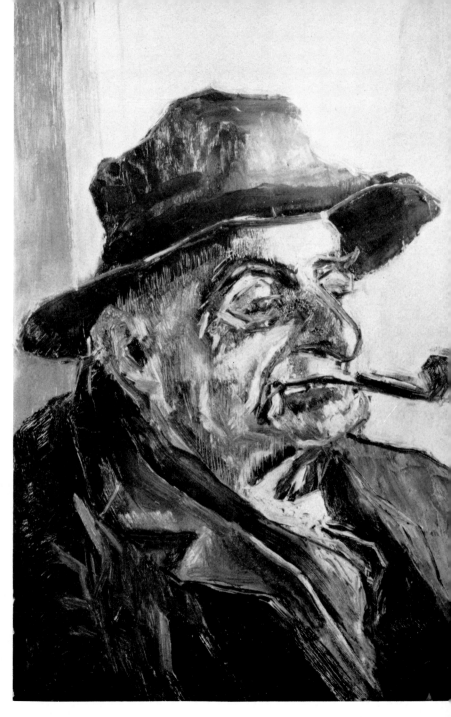

AGE WITH PIPE (see p. 172)

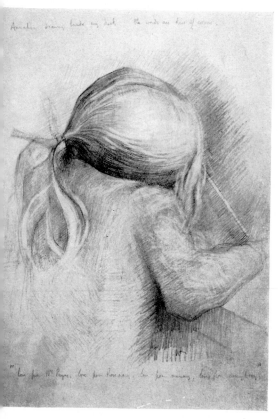

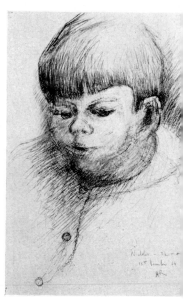

Left ANNALISA DRAWING AT MY DESK
Right Nicholas at $3\frac{1}{2}$

Chapter two

I was back at home surrounded by all that I treasured most. It seemed almost an impossibility—a trick, a hallucination—so that I returned to my studio that evening, very late at night, to sort out my drawings, notebooks and paintings. At least that was the excuse I made to myself. In fact I was searching for further affirmation of the security which had been returned to me as I had studied the drawing done in my parlour sitting-room in Berkshire—the conglomeration of objects which had become in imagination 'Queen of Them All'. There was something inside me, which in a way, wanted to fail; not to feel so secure, so ripe again for work. But there was that tiny flame of ambition, which has been my constant light and guide since the Athenian days of illness, which had been ignited by that drawing and was clamouring for recognition. By now I knew well my inconsistencies, my burning battling opposites, but I also knew much more fully by what power and means these bursting forces of opposition might be welded safely together—to

make paintings and drawings, poems and prose writings.

In a sense, all that matters in life, is learning how to start again. All life is a business of constant stopping and starting. By now I might have claimed a professional's skill in this important aspect of life.

I retired to my studio, late that night, for two opposing reasons, which were distinctly linked. To ascertain whether I was restored again to health (to quench the 'fail bug' instinct if you like) and, if this test were passed, to decide up which steps my next footfalls might—or must—proceed.

Again I looked carefully through my work. Not, as I've admitted earlier, really to 'sort out' work, in the sense that one carefully selects for an exhibition, but to reaffirm the security which I desperately required, and perhaps hoped *not* to find amongst my drawers and racks, notebooks and folders. I could then, quite easily, blame it all on 'my work'. What I had been looking for, simply wasn't there. And *how* could I re-start life with such barren means behind me? Oh yes, with the fortitude and skill of the ancient Israelites, I could have made bricks without straw. . . . It was then, whilst I was allowing such self-indulgent, self-pitying patterns of thought to float through my mind, that the real crux of the matter startled me to my senses. What exactly *was* I looking for? A folder full of Leonardolike drawings, a recent lithograph printed with Senefelder's skill? Or just a small sketch close in tone and feeling to one of Rembrandt's psalm-of-sketches? The Golden Chain itself, glittering and unbroken at either end —umbilically secure?

I faced this one with honesty. It was re-affirmation of some connective kernel, cord for which I was searching. For a time I could not place the answer any more accurately or precisely than that.

But it was no coincidence which stopped me, as I laid

out the wide variety of drawings in neat piles, when I came upon some drawings which I had made of nurses at three different stages in my life. Each stage reflected a different interior aspect of myself and yet were sufficiently linked to be 'mine' rather than any other person's.

The first section were made in Greece whilst I had been so critically ill in 1946, and was for a time entirely dependent upon the nurses for my hour to hour requirements. Four of these dramatic drawings of nurses held my attention. The nurse at work. The second section was best symbolized by a drawing done whilst the injection of Omnaponscopolamine percolated gently and soothingly round my body before an operation at Queen Mary's Hospital, Roehampton, in 1955. And the third was a drawing which I had made of my wife, soon after we married in 1958, when she worked for a few months as a part-time nurse in The Wells Cottage Hospital.

It was this latter drawing which opened up the lock gates which were enclosing a multitude of memories. I had made quite a number of drawings of Anneka in uniform when she returned to the cottage in the evenings. I remembered the feeling of security which these drawings had given to me, Anneka dressed so neatly and with that almost sanctified sensuality which is, in fact, 'the magic of a nurse'. The 'don't come near me, touch me—come hither combination' which has beguiled so many patients into believing that eternal love is found only at the bedside. I remembered, just because I had suffered from such temptations and seeming humiliations, way back in Greece in 1946—I remembered the guilt which part of me felt when making those drawings of Anneka. As I made those drawings of Anneka in uniform, I had been linked to a host of memories which I thought long forgotten. Later, I was to record some of these mixed and most natural feelings in my first book *The Pendulum*. For this

reason I will quote a few lines from this book, because they sum up succinctly the conflicting feuds which battled themselves within my mind—when I drew Anneka in 1958. And after this, I will look much more closely at these three stages of my life via those three sets of drawings.

Greece 1946. 'A certain summer stillness surrounded those first delicate days of recovery. Drained of emotion, and often drugged into oblivion, I grazed peacefully in a calm green meadow. The rustle of a nurse's apron, close to the bed, reminded me of the gentle stirrings of fresh summer leaves. I longed to put out my hand and touch this virgin white, to be part of the gentle rustle and to bury myself in its cool embrace. My fragile thin body was echoed in the narrow white vertical apron pleats, pressed like myself almost to extinction; they tempted me to link my compression with theirs, calmly ascending the slim track, until together we met the contrasting blue belt, and married in the harshness of the glistening buckle. I recognized the severity of the almost shiny starched lower seam which flashed sharply against the black stockings; and when for a moment it touched my arm or body, it both kissed and cut me.' A little later in the book, I described my intense sense of guilt when the pretty nurse who was looking after me asked when I was going to draw her. 'The request seemed indecent in my mind, when during the drawing I would strip her of her formality and her uniform.'

When I made those drawings of Anneka in uniform, I knew again intimately those conflicts recognized in illness —and recognized the forces of opposition within myself and so necessary to the making of an artist. But when one is involved with a drawing or painting, the 'sex wish' is sublimated entirely to a sensuous mysticism—wherein one 'makes love' mainly through the intellect and reason. One is denied any thought of intercourse, through the art of

intellect and reason combining in a special rapture of their own. But one is always aware of the contra-relationships, the symbols which beckon and dispel one constantly through life. In the case of the nurse's uniform, recalled from Greece in 1946 through my marriage with Anneka, I used instinctively—and yet deliberately as an artist—such contrasts as: 'touch this virgin white'—how timid compared to the next few words asking for sublimation: 'to be part of the gentle rustle and to bury myself in its cool embrace'. I think my point is best made in the passage which recognizes softness and severity and the act of kissing/cutting as part of the potentially same sensuous symphony—the reconciliation of seeming opposites. A sculptor cuts or chisels to excavate and reveal his stone, a process of 'planing smooth' through rough cuts and gouges. Kissing is another form of excavation, or expansion outside ourselves through whose 'smoothing plane' we evolve. I had known, by instinct, when so very ill in Greece, the proximity of such opposites—and read their necessary conciliation in the surface values of the 'res' around me. In particular the nurse's uniform symbolized a most subtle combination of sensuous and spiritual values upon which so many writers have cashed in on, combining a most human instinct with most superficial writing.

It was through such meaningful interpretations that my sanity was restored, however much guilt I may have suffered during those imprisoned days. They restored the potential power of poetry within me and inscaped my future realms of thought and work.

I made those drawings of a nurse at work in 1946 in Greece for two main reasons. First, to explore as dramatically as possible, within the limitations of my youthful skill and illness, the intense drama in which I was the focal point. Something inside me whispered that such efforts would not be wasted, that one day I should be able to use

these terrifying experiences of humiliation and pain in a really positive way. It was Aldous Huxley's book, *The Doors of Perception*—some fifteen years later—which was the final signal that these extraordinary experiences were my responsibility to relate, if only to discover more about my complex self. Secondly, I knew instinctively that during the making of these drawings—whatever the results might be aesthetically—I should exorcise much of that momentary suffering. And so I drew, from memory, those active moments when the nurse was dressing my legs and the pain within my veins was echoed in the knife blade shafts of veil which flashed to right and left above them. I had watched the nurse at work hypnotized by that swift swerving safeguarding veil. As I drew, it seemed that the blade thin sharpness of this veil took away my pain for purification, concealing it neatly within its folds to return it less intense, swathed in its cool and contemplative embrace. Constantly whilst the nurse worked, and later when I drew, the image of sacred healing through the sanctity of the veil swept through me. I drew what I dared not touch, for it was Holy and in its honour I attempted to render its symbolic power through my pencil.

With what perception and profundity the Roman Catholic Church understands its attendant powers of symbolic vestments. How profoundly is one aware, during great sickness, of the power of signs and symbols, when the veil shades many sorrows and the bib protects more than bosom's breasts.

I drew the light and dark of the nurse's uniform attempting to represent those conflicting tonalties within myself and to invest them with the same distinctive unity. On one of the drawings I scribbled, 'Black and white made ONE through the greyness of our matter'. I drew through those sketches the stab of pain stemmed as the seam of an apron turns back its streaming length. The

138

clothes turned back, the sleeves rolled up, the seam made whole—the calm, neat stitches mine to share. I drew to convert an act of drama to a drama of an act, in which play I had been for a while selected for a central role.

Nine years later I had to spend several months in Queen Mary's Hospital, Roehampton, which at that time was the hospital in the London area dealing with war disabilities. I drew much of the time, read widely and attempted my first novel which was to be called *Away From The Flowing Stream*. At least I knew myself much better than I admitted at that time, and all my intuitions whispered that I must lead a life 'away from the madding crowd'. I tried this 'the easy way'—through a novel exploring this subject. I was not yet ready or prepared to be *too* far from the madding crowd.

A painter or writer needs solitude more than his pen, paints and brushes. Art is a most distinctive form of prayer. It is a joyous penance form of prayer. One can easily understand why Franz Kafka wished his writings, unpublished in his lifetime, to be destroyed at death—for as W. H. Auden has pointed out, his art was one of continuous inner prayer. But I believe all serious 'making' work to be an act of prayer, and although one fully understands that prayer is a most private affair (and therefore has no need of later 'showing')—I think such personal, painful, self-inquisiting thought has a distinctive responsibility, and purpose, to be seen and read by a wide public later. I know Max Brod was right in his decision to edit and publish that great writer's work, whatever Kafka's personal wishes may have been. The world would be a much poorer place without the writings of Vincent Van Gogh—which too were most distinctly full of prayer, in every sense of the word.

I am not straying from my point in these last two paragraphs because what I have to say about the drawing of a

nurse at Roehampton in 1955, whilst the sedative drug Omnaponscopolomine gently percolated around my system, is closely connected with matters related to prayer and meditation. A hospital ward has more potential for true meditation than any other institution except of course a monastery. In a ward one has almost limitless time for deep thinking—and what is more important, the 'trigger' of painful life and death around one to make this a necessary requisite for survival.

In a sense I was 'high' when I made that fluent sketch of a nurse near my bed shortly after being given the sedative injection. She had been sent down the ward to learn why I had not 'gone to drowsiness', as most patients do after this most relaxing of antidotes to worrying. I had been determined, almost at any cost, to record in some way my feelings and reactions whilst the fear was being extracted from me and I was fast being relieved of any form of responsibility. As related in *The Pendulum*, I had written in a notebook during the Omnaponscopolomine period connected with the first operation in that hospital. This time I had decided to draw. I made a list of brief notes shortly after this drawing, to remind me of some of the matters which had stirred within me whilst working in that drug-drowsy-dreamy state. Before giving you these actual notes, I must mention that the staff nurse beside my bed, for a time, scarcely seemed able to handle the situation. She was new (I had never seen her before) and her quiet persuasions to relax and cease drawing had little effect for some ten minutes. She seemed as hypnotized by the situation as I was by the drug and my dare-devil-drawing activities. And when I made my notes, this comment topped the list.

I have previously stated that I am not straying from my point, when giving space and time to thought upon the contemplative life necessary to an artist, so readily at hand

in a hospital ward. This is particularly true when a person of potential intellect and deep thought (however muddled it may be at times) is given an injection of Omnaponsco-polomine, which rids the patient of worldly desires, basic sex and the usual blockages to spiritual contemplation. Whatever I may have been in God's eyes, at that particular moment, I was through that injection being versed—as far as I could understand it—in one part of the contemplative life. I continue to recognize the validity of such a situation for a certain form of true meditation. The argument that drink does the same for man is a strong one. My only defence against that is that I did not indulgently choose a painful operation which necessitated partial oblivion before it was performed. I simply attempted to use that situation as positively as I could at that time. My notes, made through drug-blurred vision, bear some testimony to this. I tried to use the Thesaurus by my bedside, but my eyes co-operated little in this act.

> Hypnotic Rhythm
> Flowing Rhythm
> Endless flow
> Uprightness
> Starchiness
> Preserver
> Upkeeper of Uprightness
> Cool, cool, cool . . .
> Defender
> Breastwork/lunette
> Lady Bountiful
> Present help in Time of Trouble
> Salt of the Earth
> Saint
> Fresh
> Veil of Visions/Visions of Veils

New/Untainted
Waiting/Calling
White Flower Pot
Streamers of Delight
Unfurled
Flag-flying
Trimly, trimmed.

I cannot decipher the remaining dozen words after 'trimly, trimmed' but am quite confident that they add nothing to the visual and verbal picture which this young staff nurse implanted upon my drowsy state.

I drew her standing by my bed, arms behind her back, talking quietly with a hint of Scottish accent. She appeared trimly, trimmed and yet to be unfurling like a national flag in an April breeze. Purposely I use the words 'national flag', for her presence seemed far from parochial; to have described her as like an 'international flag' would destroy the image for which I am seeking. She was, in a way, an impersonal symbol closely related to a lifetime of known and accepted habits. This is the power of a national flag, the magic of which all nations recognize and use to the full.

I drew her as an unfurling flag, a Regalian Queen, a streamer of pure delight veiled in visions capped by a crown fashioned in the form of a glazed white flower pot. At times she seemed to cascade in the most gentle rustle of breezes, and at others she was swept by a rapturous volume of wind. She was spring and summer all in one, lithe against the winter whiteness and the blast of storms. She was the storm made still, suspended seasons unified to one, the season of the fifth, the unknown season of the soul.

When I made that drawing, and many others, of Anneka in uniform in our small cottage winter warm with

blazing wood, high above Wells late in the year of 1958, I found again the link between my strong sexual passions and instinctive delights in creative work and thought. Recently I discovered some very profound words upon this subject written by the great American poet, William Carlos Williams. I cannot do better than quote them, for they so perfectly sum up the state and situation which I am attempting to relate.

> I am extremely sexual in my desires: I carry them everywhere and at all times. I think that from that arises the drive which empowers us all. Given that drive, a man does with it what his mind directs. In the manner in which he directs that power lies his secret. We always try to hide the secret of our lives from the general stare. What I believe to be the hidden core of my life will not easily be deciphered, even when I tell, as here, the outer circumstances.

Generalizations about people or groups of people are dangerous. One takes with a pinch of salt, in this country, the foreigners' reaction to our police force. 'All your policemen are just swell.' But there is a sufficient grain of truth, let's say 'a need required by the many', to make such a statement ring almost true.

And it is a fact that 'the whole world' loves a nurse. It is upon her skill, which cannot be separated from her womanhood, that we depend when really ill. What person can truthfully declare, as Williams has, that they have not found amongst a group of prize-waiting nurses, seated in their starched uniforms upon a platform, some of the most beautiful women in the world?

I, for one, certainly cannot. Because they are; and in a way these women are not directly linked with the pain of the world. They are symbols of what most people at heart

need most, in this dangerous treacherous world—the dispensers of motherhood and care. The world of medicine was not lacking in psychology when it chose its women aids or the dress they wear.

Chapter three

In the preamble to this book, I stated that it was involved with seeing, feeling, thinking and doing. That it was an attempt at the conjunction of opposites. The background from which this book is drawn is approximately eight years of my daily life as a person, painter—sometime patient—writer and father. The 'picture' would not be complete without a closer look at two aspects of my life which play an important part in my work. My job as a teacher, a lecturer in painting at an important Provincial Art College, and my interest in the 'landscape of the face and mind'. A painter of portraits—or landscapes of the face—must necessarily be profoundly involved with the mind of his subject; if he is not, the portrait will be only a surface one. In these last two chapters I shall be giving you both visual and verbal images of a few of the people whose portraits I have attempted to make. I shall attempt to give you the visual discoveries which I have made alongside the thoughts which occurred to me during their 'making'. And in one

instance I shall put forward a faithful record of a 'conversation'—more a monologue—with an evening class student which fired my imagination as a poetic revelation of the loneliness of the human animal and its desperate need for both security and love. Without this descriptive passage, I would not feel that I had given you the true sum of my profound interest in the 'landscape of the human face and mind'. The lines of that tragic monologue are etched more clearly within my mind than those visual symbols which were inscribed with pens and pencils upon the paper.

Child and man. Youth and old age. The minds of the old throw off, like we do to the 'ancients', a slope of remembrance through an ascent of brow accentuated, more inclined through age. An inclined angle, thinned hair defined, declines old age. Capitas, Capitas, Capitas. Thought comes back to them as it does to us through the Sphinx. One moment the face is inscrutable, the next warmed for a second by a remembrance long thought dead. The smile is a silent one—all smiles are inward and silent—but the old man's smile is more inward and silent, less prolonged. Gently the urinals flush, water cascades, and all again is the same. Almost inscrutably clean, if it wasn't for the yellow ochred dribbles of stain. A smile not put on, part parcel of the past—put off at the twinge of a knuckle on knee. A joint, a sharp bend in the nose cracked through ball and foot—bent poise shaped, jointed long ago—tomahawk fossilized from youth. The ancient crow flies straight no more. Strange how this inclined ascent of brow offers a symbol of decline. Now no eagle flies overhead.

What was it the old man said? I scarcely caught the murmur. That Old Tom was dead? Tom, who sixty years before—it's said—sold his fiancée to young Fred for half a guinea and ten pints of scrumpy. Of course half a guinea

was half a guinea then. But I doubt if scrumpy's changed as much as that! 'Arr—yesterdaye they puts old-Tom-down' the old man said. But there were no vultures overhead. Just two old ladies and one middle-aged man, and two diggers by the grave.

I asked the bent old man if he would sit for me again tomorrow and all he said was: 'Old Tom's dead.' So I drew a young girl's hair against that death, to make for myself a resurrection. The next day the old man saw it. 'That girl's hair is fair,' he said and did not utter for an hour. We were both bound in silence—and to compare the dark dug earth and that silk fine hair. I did not utter because the image of a word is as abstract as a fresh dug grave. And graves are made to measure. Well almost . . .

The particular angle of a forehead, precise exact; 'the semi-colon upon the face of life,' I thought as I drew that aged, shaggy head—carried forward, slightly hunched—enclosed and sunken within the shoulders. Shoulders sunken to match the eyes. A semi-colon carries forward too, does not quite bring to a halt.

The particular abandonment of youthful hair, cascading, twining, twisting, dangling, dancing—turning upward, curling, coiling—daring, continuously constructing fresh rivulets and waves of splendour. Caves fashioned, explored, exchanged for other caverns, some more deep, some less sure. But always fine. The rhyme of rhythmic locks with no apparent care. The streams and rivulets of youthful hair, born like the rose to be gazed upon.

Old age and youth. Do not compare, lest you entwine some golden hairs with the golden watch, and chain, presented in much later years. Maintain the time yourself, without a watch at hand, lest the dial deals death to all your dearest dreams. Remember that you do not look for shadows—'eh what old man?'—they emanate from sun. And *never*, *never* make a deal with time. Time deals the

cards to us, we mortals cannot deal to time. Youth is youthful for its own sake, not for the sake of age. 'Tom's gone, Tom's dead,' the old man said once again. The old man's eyes were almost gone, the lids were slit and almost shut, four rusted scythes in miniature appeared; and whispered, I would guess, the same four words, time and time again. An old man's benediction, blessed prayer. Again, for a second, that wintry shaft of smile. What did it disclose, disguise—cloaked with the same shade of those hooded eyes?

The hooded eyes of age, hiding and revealing hurt—drooping at half mast for what is passed and bound to come. What eyes do not reveal in age are not hidden by the lids. The more they close—those still lively loads of lids—the more they do reveal.

An evening student in middle age. I have of course changed his name and give you his portrait, this time, in words alone. The words are his; I jotted them down directly after evening class, whilst their echoes still rang in mind.

But if you can imagine a face drawn by Rembrandt, in outline—without any shading put in, then you know exactly what Mr. Trail looked like.

War does this to some people. Often it makes the shadows deeper, darker, more hollow; but just a few, like Mr. Trail, have it all wiped away when they've been for four years in a prisoner-of-war camp in Japan on the edge of a jungle.

I can't say whether his voice, which toned his face, was the same—I mean before the last war; it's really impossible to imagine how it *might* have been.

I knew Mr. Trail about three years ago. He came to my evening classes in painting at the Art College; late on a Friday evening—6.30 to 8.30 p.m. In the winter it was

very dark round the house where we worked which had a row of monkey-puzzle trees either side of the road. Only there were two missing on the opposite pavement; but you couldn't see any of them after seven o'clock on a winter's evening. He drew mostly figures or faces; he made the faces very much like his own. But he usually put a bit of shading in—after the rest period. His face did change a little, for a moment I think; but perhaps it was my imagination; when I showed him a book of Goya's drawings.

As I say, you couldn't see the monkey-puzzle trees after seven o'clock on a winter's evening. But you knew they were still there. Except for the two missing ones.

He walked about two miles, he told me, to these classes. In any weather. They meant so much to him, he told me. He was always apologetic if he couldn't make the two evenings a week. Tuesdays and Fridays. Sometimes, he told me, he attended the Playwriting Classes at The Institute; on a Tuesday. He was writing a comedy he told me. He didn't disclose the plot, or any of the funny lines; he just said he'd fixed up a sort of writing room in their old greenhouse, as his wife didn't like him writing in their living-room, which they used only on Sundays; and she thought it indecent (he used another word which I forget) him writing up in their bedroom.

He told me they had six children. He pronounced the word 'children' to embrace both sexes; you couldn't guess whether he had two boys and four girls, or four girls and two boys, or three of each etcetera. They seemed permanently (all of them) stymied at an average age of fourteen. I tried to think of them differently but it didn't work.

Seven years, he told me, he'd been working on that play.

Oh yes, once he assured me that there were at least

seven really funny lines in it; in this seven-year comedy he was still working upon; but they didn't quite fit.

Was his wife interested in the play?

Well, not really, but they did share everything else, he hastened to assure me, everything that was except the interior decoration of their house. They'd agreed completely on its name. RESTAWHILE. They'd both thought that was just right. And they'd gone together to have an oak slice 'cut', inscribed with the name, in sort of modern gothic lettering; the day after they'd bought the house. That was sixteen, no seventeen years ago. It was a lovely summer that year at RESTAWHILE, well almost everywhere —that year—in England. But he'd been told that it wasn't so hot in Scotland. Well that was bound to be, you couldn't have everything everywhere, just right at the same time, could you. The end of his sentences were never intended as questions. They were his way of confirming his own private philosophy to himself. They were as much part of Mr. Trail, these non-interrogative endings, as the faded fawn muffler which he always wore after September. He usually took it off when he was drawing. No, they didn't see eye to eye on the interior decoration of their house. But it didn't really matter. All that amount. Not really. Then, with a hint of pride, he told me how his wife had used five different wallpapers in their living-room. Their Front Room. For special Sunday use; and special occasions of course. Like Christmas Day.

Of course it was small. Or she'd have used more. She'd bought six different papers. Expensive ones too. But there wasn't space for the sixth. It didn't look right on the cupboard doors. They'd both agreed on that. He didn't like very much, the wallpaper on the ceiling, but he hadn't said anything. I mean you don't look, often, at the ceiling on a Sunday afternoon with the 'in-laws' in to dinner and tea. And the blue china with stripes up and down it, and

red and yellow roses in between, was fine. Her mother had given it them as a wedding present. It was beautiful in fact, he said. Though over the years, of course, with the children and all, four of the cups had got cracked; and one of the saucers; but you couldn't, easily, see the joins—anyway not in the winter—(when you couldn't see the monkey-puzzle trees) now that he'd stuck them together with that new, waterproof, colourless, sticky tube stuff. He could never remember its name. But it was good.

He was hoping to have saved enough money to put in some heating in the greenhouse—soon. It was cold working out there; not in the Summer of course; they hadn't grown flowers in it for years; he couldn't remember exactly how many; probably eight; it might be nine. About nine he thought. The wife kept her potatoes in it, the old prams and the cot. There wasn't anywhere else. And he didn't need it all for his writing. He'd patched up the roof several times; there'd been no leaks at all last year. Well only a very small one near the door. And that closed perfectly now he'd re-hung it. His wife always said, until about seven years ago, that you never knew when the cot and prams might not come in handy again. That was seven years ago; about then, he told me, but the cot and prams were still there. They hadn't come in handy; still he didn't like to say anything.

We often talked during the model's rest period at 7.15; over coffee in plastic beakers; when emptied, with just a hint of moisture left at the bottom, their vacuity closely resembled Mr. Trail.

But the cups allowed much of their warmth to the imbiber's hands.

It was completely dry, that linear drawn face of his, without the shading put in; dry as a bone.

It was late in the Autumn Term; early December;

nobody, except perhaps the cats, could see the monkey-puzzle trees after seven o'clock; of course even the cats wouldn't have seen the two which were missing. I had arranged a new variety of still lives around the studio; some fabrics held apples, for structural type drawings, for those who appreciated Cézanne's type of work, to put it in the words of one of the old ladies attending these classes. In a corner I had arranged a whole pile of socks, tucked into each other, which my wife had been about to throw out of the house. They held a certain fascination for me, this pile of tucked in socks, and I wanted to convey this to the evening students.

I tried very hard. Most of the results proved I hadn't succeeded.

The rest period had become a definite ritual. The two warm beakers; we paid alternate weeks; where we sat; how we drank. All Mr Trail's actions were tantalizingly, fascinatingly passive.

It was all the same, the evening I'm writing about. Neither of us talked during the first sugary sips of the mixture. Mr. Trail sitting, almost apologetically, on the corner of the large, crimson, scratched table which filled the whole of one wall. Only he set the cup down beside him sooner than he usually did. And stared down at the floor. He began talking, scarcely lifting his gaze from the floor, or his head; his shoes hadn't been shone for a month or more; they were, or had been, black; his trousers thin, light grey; his shoes were squat, square at the toes; a small dent lay pressed neatly, rather seriously, upon the right toe cap.

I imagined his large, bony big right toe—dented a little too.

But with no inflammation around it. A tiny, unprotesting, saucerlike shape, a miniature reflection of the larger dent apologetic for thus being dented. Some strands of

thin, colourless hair moved a fraction as he addressed the floor.

'It's funny, Mr. Tutor, but those socks—those socks in there,' he didn't look up or in the direction of the studio, 'it's funny, they remind me of the war. A girl I knew. Well, two girls I knew. I hadn't thought about them like that for years and years. For years . . .'

For a moment I was horrified. What *had* I done? Had I brought into these studios some long-hidden, traumatic memory from the prison camps of the far Eastern war? Had those socks . . . ?

He looked up. 'Yes, they took me right back to Salisbury Plain; those bright blue socks in there; right back to Salisbury Plain—when was it? The first year of the war? No, the second year I think. Yes, the second; that hard winter of 1941. I expect you remember. There was snow everywhere—all over the Plain, over everywhere really— you couldn't see anything for snow, for miles and miles around. Miles and miles . . .' He paused, misted and back on the Plain. 'Nothing except Nissen Huts of course, and posts and wire. It looked very dark, that barbed wire that year. You probably remember too.'

'Yes it must have been January '41'—a hint of daring to his voice by omitting the 19, ''41, that's when it would be; perhaps February; of course it could have been March; no there weren't any winds—I mean not to speak of. Not so's you'd notice; January I expect. Well it doesn't matter too much. January or February, and freezing cold all around. And all the snow everywhere. You couldn't get home for leaves, the roads were frozen so bad. Not even the officers couldn't get home. Not them. Not for those few weeks. Well they seemed like months. Years really. We were all stuck on the Plain. All in the same boat you might say, if you see what I mean. Right in the middle. Well my hut was quite near the road . . .' Again he paused, judging the

distance between his Nissen hut and the snow clogged road. 'About twenty yards, I suppose. Nothing to do really. Well of course we all dug a lot. You know to clear the snow a bit. You have to when it's piled up on a plain like that all around you. Have you ever been on a plain with snow all around you?' He never wanted or waited my answer. 'Well you know what it's like; we all sat round fires, when you could get near one; but there weren't too many of those around at that time. Just one stove to forty-odd men. One stove to a hut. You couldn't always get near the stove, till late in the evening. Not unless you were a Corporal or something important like that. Of course the Sergeants were all right. Yes, I remember now, there were forty-seven men in our hut; we all wrote letters, lots and lots of letters and hoped they'd get through. You never really knew in war-time, did you, with piles of snow and things around . . .' The sadness in his voice changed as he continued his monologue; just a little.

'I had two girl friends at that time; two girls; both lovely girls; but different of course; but they were both lovely girls—in their own ways; quite different really; quite different. I mean Agnes was the comely one; well not exactly comely, not at all pretty, well sort of plain in a friendly sort of way. No—not at all pretty; and she didn't write many letters; she wasn't the letter writing sort if you know what I mean. But she knitted the most wonderful socks. Each week—yes I remember it was January, because of her first note; she put it with the socks. "Here's yr. Jan. pair as promised Agnes." They were wonderful socks. That Jan pair were thick and bright and blue. Nobody minded what you wore in all that snow. Not even the Sergeants. And each week, the whole of that bad winter, she sent me two pairs of socks, knitted with her own pair of hands, two pairs of socks each week and two bars of chocolate. You couldn't get chocolate for love or

money at that time of the war. I don't know how Agnes got those chocolate bars; I mean she didn't have much money; as I said, she never wrote letters; just notes, signed in her own hand, Agnes. I must have had two dozen pairs the time the winter was over. They looked sort of funny in my locker when the spring came. But I never told her of course. Not all girl friends sent their boys chocolate bars each week, and two pairs of handknitted new socks right through that winter. Or any winter, I suppose. Did they. It was a sort of homely gesture. It really made me feel wanted in a way.

'Then there was June.' Here Mr. Trail paused whilst his mind switched from two dozen pairs of handknitted socks on Salisbury Plain, and all the chocolate bars—to June. His face brightened distinctly for a second. It clouded again back to its usual expression as he continued. 'June. Now she was quite different. Agnes never wrote letters; just notes as I've said; she was never a one for words, but her socks and the chocolate bars made up for them. I mean she was in those bars and socks, if you see what I mean. But June was quite different. And ever so beautiful; she got all sorts of whistles when she walked out in the streets. June was beautiful. Like a film star June was—then. And her letters. Her letters were pages and pages long. And there was always a poem, a poem in every letter. And on special days, like my birthday—when Agnes sent me three pairs of socks, June—she wrote her whole letter in poetry. Ever so beautiful poetry. You'd have liked it. Real poetry. Of course she never knitted me socks, or chocolate bars—I mean sent bars of chocolate—but you can't have everything, can you. I waited for these letters, sometimes she scented them and perfume was almost impossible to get those days; and ever so expensive.' He paused and withdrew a very old wallet from his trouser hip pocket; 'I've got two of them here; of course the perfume's worn off

but the poetry's still there.' He didn't hand me the two heavily creased pieces of notepaper. 'I patched them up with some Sellotape a few years ago; I don't think it matters, do you.' Unfolding the worn out pieces of paper, he gazed down at the faded writing which proclaimed the years of hip pocket travels they'd made sandwiched between Mr. Trail's bottom and all the seats he'd sat upon. Bending forward, he peered very closely at them. 'It's a bit difficult to read these days; but—well I know the second one by heart, almost, now.'

' "Dear J." ' Without looking up he continued; 'she always called me J.—in those days—it was short for Jack. It was a sort of joke, in those days, she starting "Dear J." and ending with "your adoring one and only star gazing J." Her name being June. We had some jokes in those days. It was different, in a way, those days—even with a war on one's hands. Yes we joked a lot in those days. I don't know what we had to laugh about, but we did, mind you. We joked all the time, June and me. Agnes never called me J. Or anything poetic like that; well with all those socks she didn't need to really, did she. But June, —June couldn't help it; it was part of her you might say; I mean those jokes in those days. You might say that the socks kept my feet warm and the poetry,' here he paused, lost for words for a moment, 'the poetry kept me warm in another sort of way, if you see what I mean.' Again he paused; longer this time. 'It's funny—just words doing that.' He looked up as if asking me a question. 'You wouldn't believe words warming like socks, only differently, would you really.' His eyes still questioned, but his sentence had no interrogation mark at its end.

'I never told Agnes of course. I don't know what I'd have done without those socks.' He paused. 'And all those chocolate bars.' But how I waited for all those letters. She wrote lovely poetry in those days, I think I mentioned that

before. Those letters—well I remember one of them was twenty-four pages long. One page for each hour of the day.' 'And night,' he added.

'Well, at the end of that year I was sent overseas. We all were—almost. There was nothing wrong with me except athlete's foot,—which I must say I found funny at the time, me not being at all athletic. Though I did once win a three-legged race with June. She had lovely legs. Beautiful they were in those days. Round about '41, as I've said before—when we were stuck on the plain. I went overseas —like most of us did, I expect you remember, and got caught by the Japs a month after we landed. It helped to think of Agnes and June, it helped when you were being tortured—not that I got it as bad as some. It helped to think of Agnes and June. I remembered those parcels. Of course none got through to the camp. But those parcels arriving each week on the Plain, with them socks in them, all of Agnes was "in" them if you see what I mean, even though she didn't write letters. She was in all those pairs of socks. It may sound silly now, but it didn't thinking about them, in prison camp. And June, I don't mind telling you, I thought a lot about her lovely legs, not dirty thoughts of course—beautiful thoughts about her legs. Yes, I thought a lot about June's legs in those days; and other things too mind you. Funny, I didn't think so much about her poetry then, but I thought about all those pages and pages of letters. I've never really been a one for poetry and that sort of thing; playwriting and art have always been more in my line; but of course I never told June. I mean her poems, well she was in them—if you see what I mean—like Agnes was in all those pairs of socks. Yes I thought a lot about Agnes and June in prison camp.'

'When the war finished, they told us and we came home. You remember. In 1945. It was good to be back home. It was a bit lonely though, with no job to start with. But I got

157

one sooner than some. It was then the difficulty started. I felt it was time I got married. Set up a home, settled down —you know what I mean. But which one of them was I to choose? It wasn't easy to decide I can tell you. Should I choose Agnes who wasn't good at writing letters and all that—but was a smashing knitter of socks—or June who didn't knit but wrote all that lovely stuff to me on Salisbury Plain in the snow, and had beautiful legs. Well, she was beautiful all over—in those days.

'It took me three months to decide. It wasn't easy I can tell you; you'd have found it difficult too, I expect, being an arty type and all that. Anyway at last I made up my mind. As I say, it wasn't at all easy, and it didn't seem fair on either of them, to just toss a coin. Not in a serious matter like marriage.' Mr. Trail looked down at the Sellotaped letter and then across to the studio in which the still life of bright blue socks sat patiently waiting his return.

'Well—I married Agnes; I mean she'd knitted me all those socks on Salisbury Plain.' He paused looking down once more at the much travelled letter of love. 'But she hasn't knitted me a single pair since. I get them at Marks and Sparks when I need them. Wool's expensive these days isn't it, the real thick friendly sort. You can really get anything you want these days at Marks and Sparks.'

As an evening class teacher, you are often stymied in the rest periods by the Mr. Trail's of this world. But in these self-centred revelations, so artlessly told, there is a distinct poetry of revelation about the real tragedies of mankind.

'Of course I don't say all the socks are pure wool at Marks and Sparks. . . .'

Chapter four

This book would not be complete without the link of one particular golden chain, which changed the course of my working life. This was my meeting, stay and two-day private tutorial with Robert Frost in the fall of 1962, at his home in Ripton, Vermont. It was Robert Frost who encouraged me to continue work on my first book—*The Pendulum*—when it was a few chapters old and seemed to be a hopeless task.

When Robert Frost had presented four of my drawings early in 1962 to his collection at the Jones Library at Amherst, Massachusetts, I had felt it in my heart that we might meet one day. We had corresponded and his letter had ended with the words 'I hope one day our paths may cross'. Little did I think or dream that that day would be so soon.

Towards the end of that same year—the summer of 1962—I won a small award to the States for my painting. I dropped a line to Robert Frost letting him know that our paths were more ready to cross; but on the boat I learnt

of the poet's journey to Russia—which was much in the news at that time and cursed my luck—and was not even generous enough to recognize the good fortune it was for the Communist world as a whole and the Russian people in particular.

And then a fortnight or so after my arrival in New York, while staying in a friend's apartment, I received a message that I was to ring Mr. Frost's secretary, Mrs. Kay Morrison, who lived close by to Frost, both in Vermont and, during term time, at Cambridge. For about twenty-five years she, and her husband Professor Theodore Morrison, had guarded and guided, aided and secretaried Robert Frost, so that he had been entirely free to write those immortal poems so close to his heart and the soil from which he had at one time scratched a living.

I rang. Mrs. Morrison told me—and my heart leapt a beat or two—that Mr. Frost would like to meet me and could I be at White River Junction by 2.40 a.m., where a car would take me on to a hotel in Dartmouth. There they were to meet me—soon after breakfast—she and Robert Frost. We could then decide plans for the day. My heart was once again affected by the use of the plural pronoun. I just could *not* believe my good fortune and that this great and magic poet was really coming down to meet *me*—all that seventy miles from his chalet home in Ripton, to discuss art and poetry and the opening chapters of my complex book *The Pendulum*.

I slept little on the hotel sofa. I had not enough money to take a room or bath. But if I had been lying in one of Solomon's great love halls, I could not have been a happier man.

Dartmouth is a University College—one of the famous Ivy League. Its charm depends much upon the almost edible wooden neo-Georgian façades which vie with each other for perfection, grace and ease. It is a beautifully

relaxed country town, dreaming in the way that Cambridge does in England. And Nervi, building his massive athletic stadium, just on the outskirts, was strangely not out of place—despite the concrete modernity—for in his magnificent design there was singularity and grandeur too. So that you had a sort of modern grandfather proudly watching his aged well-tried grandchildren—and new and old blend into one—as they can anywhere when there is plan of purpose married to a well tuned eye and heart.

And so we met.

First there was a luncheon for us in the hotel in a special upstairs room—Robert Frost, Mrs. Morrison, the Dean of the Faculty—Mr. Arthur Jensen, the Chief Librarian, Mr. Latham and myself. It was a lunch full of laughter and delight—me very timid at the start, next to Frost—but blossoming forth aided by the fine claret which we drank. And so that when the Principal—I thought merely in claret laughter—asked me if I would be interested in teaching at his College—I too laughed and readily agreed that well I might. Then the real generosity and tenderness of Frost spoke to me, in voice, for the first time. He leant over and said, 'Think it over, boy, I'll be a referee if you do decide to have a shot.' My heart indeed skipped a beat, and I flushed beetroot red in sheer delight.

I must explain at this point that through a mutual friend, Frost had read the opening chapters of my attempted auto-biography *The Pendulum*. I was aware of his interest but not of his particular views at this moment. But as we got up from the table Frost pointed to some coffee spoons and cups and whispered in my ear, 'I like that part in the Greek cook-house and all those pots and pans and ladles.' Then he paused and looked out through the window. 'But it is your ward scales that really interested me—let's talk about them when we get back home.'

The poet took us round the College where he had been a freshman—so many years before. He showed us first his study room, the playing fields, the fine new hospital where we went inside—and then, turning to the Chief Librarian, Mr. Latham, he muttered something about 'his library'. And so we found ourselves in that precious room, filled with Frost's letters, notes, first editions, books, a whole patina of his past years of writing, farming, living, laid out in bookcases and shelves. I could see, and sense, that my host was brimming with pride and joy—and why not after more than forty years of almost complete neglect? He turned to me, his joy lessened a little by a sadness in his tone—'I don't write letters any more, people just sell them for money.' It was a shock to believe what he said, but I knew well how the world treats both a neglected and a famous person, and I too was sad for a moment. But soon he was lit by a passing ray of sun, and his tired old wrinkled face rustled in that smile which was somewhere poised between a beam of light and an autumn fall of leaves.

We started the drive from Dartmouth soon after three in the afternoon, Frost sitting next to Mrs. Morrison—who drove—me in the back, often craning zealously forward to glean a word or pass some thought across to both of them as we drove up to Vermont, heading for that quiet remote farmhouse in Ripton, where the Morrisons had their home—mother-close to Frost's small wooden chalet.

We stopped to do some shopping in a lazy New England town called either Windsor or Woodstock. It was a charming place, like the pre-war market town of Blewbury in England, with a minimum of shops and material obstacles to impede my mind, already swimming in country delight from the thirty or so miles of travel along New England roads. Frost was determined to do his own shopping and left Mrs. Morrison and me to spend our time in other

shops. It was obvious he wanted to be on his own. His last remark in the car had been a mutter about 'a present for Kruschev—*must* send something soon', for he had spent quite some hours with this great Russian leader on his visit. Then we parted—for an hour. Frost to his 'carriage basket' in the drug stores, and Mrs. Morrison and I to more practical affairs—like meat for the evening meal, ten pounds of potatoes and two tins of ham.

My mind wandered round this 'present business' for Kruschev. Then quite suddenly it dawned upon me. Peace had been much in my thoughts since Kruschev's name had been mentioned. I thought 'Why not a pipe of peace, why not—a Corn Cob pipe?' I rushed into a tobacconist's shop and bought five such Corn Cob pipes, all shiny yellow, corny bobbled and perfect as a pat of fresh farmhouse butter.

As I approached the car, parked near where Frost had gone to shop, I saw this poet-prophet standing, bowed a little, his wire wheelbasket still firmly held by one strong hand—while the other was stretching out to three young children (the oldest cannot have been more than eight) his hand stretched out to take an autograph book to delight, in full, these three young children. He released his hold upon the basket, and gently opened the nearest of the books—and holding it in front of him, slowly wrote inside it. By then I was near the group; a fourth and older worshipper of this great man, who was both a slow weatherwise Vermont farmer and a visionary poet, who could write of walls—'and something there is that doesn't love a wall, that sends the frozen groundswell under it and spills the upper boulders in the sun'—and of boulders themselves: 'I farm a pasture where the boulders lie as touching as a basketful of eggs.'

I could scarcely keep back my youthful excitement as we drove off again, the shopping finished. This time no

stop to Ripton. In my pocket I clutched five brand new Corn Cob pipes—and they burst forth in my hands as I exclaimed, 'Mr. Frost—how about a Corn Cob pipe for Mr. Kruschev?' He turned slowly round towards me, and that wintry face once again broke into spring delight. . . . 'That's an idea, a *real* idea, I like that . . . that's an idea . . . good . . .' No schoolboy winning his 1st XI colours could have glowed more fully at that moment. And so we came to that pasture where boulders lay, as touching as baskets full of eggs where Robert Frost lived and worked; where he had for a quarter of a century mainly entertained ideas.

We all supped in the Morrison's wooden farmhouse about eight o'clock on that September evening, Professor Theodore Morrison and his wife Kay, and Ann their grown-up married daughter. Mrs. Morrison had sent me up to Frost's chalet to call him for supper. There I found him searching for one of his cats. Once again the penetrating charm of his wintry smile spoke to me; pointing at the grass he said, 'It's all there, all there . . .' and he smiled again. The birches behind the chalet were a tangible confirmation of his joyous poem 'and one could do worse than be a swinger of birches'. We walked slowly to the house a few hundred yards, me trailing in the trampled grass which Frost had trod.

Supper was disappointing. Frost was apparently upset by something—and the conversation moved uneasily. I felt an intruder. After supper my eyes wandered back to the water-colour painting above the sitting-room fireplace. It was a romantic and telling painting of the interior of a barn—a presentation to the poet of some sort. It was a moving painting, and I found myself linking the profundity of Frost with the depths of shadow in the old shaggy barn, illumined in just one slit area. They were a pair, that painting, dark brown, sepia, grey—and Frost with his gossamer frayed white hair, despite their tonal

discrepancies. They married—in both being 'versed in country things'.

After supper—perhaps an hour later, Frost turned to me and said 'you coming up with me?' And so we walked again that downtrodden path of grass back to his chalet home.

The room was as you would expect it. It possessed that comfortable untidiness which often surrounds men at last at peace with the world, who slop about in old slippers and dig for pipes in the wrong pockets of worn out coats. And so with Robert Frost and his room—at this stage of his life.

We sat ourselves on either side of an unlit fireplace, Frost in a large armchair and myself in a smaller one. It was late and cold—and damp. Slowly the octogenarian poet lifted his heavy frame from within the chair and stood up. He stooped in front of the empty fireplace, bent down, picked up the poker and a handful of clean-cut firewood. 'Can I help you, sir?' I said in rather a public schoolboy voice. He turned round, unbent a little, and with a dry twinkle in his voice said, 'It takes a poet, m'boy to light a fire.' One could sense the twinkle in his eye, as the flames began to flicker, at his own superb metaphor. This magic metaphor may well have been used many many times before by this great poet, but his genius, speed of mind, and appreciation of the particular audience/moment made it an immediate response, rather than one of contrivance. I think this 'acting sense' allied to his other great powers—gave Frost a quality which is entirely unique outside the theatre—and which the world knows via his lectures and a recent television programme; they were performances of unique expression. I had the privilege of a four-hour personal performance in that chalet room which I shall treasure all my life.

From that moment onwards a stream of stories, ideas, thoughts, quotations, proverbs, metaphors and fable,

poured forth in that inimitable dry husky voice which was nothing as so much like the crackle of dry autumn leaves. And on they flowed.

'Those ward scales of yours in your book—balance, bullying and all that. . . . Ah, that makes me think. I like it a lot.' There was a long pause. The aged poet looked towards the ceiling. 'Yes—er—bullying—' short pause, 'Kay looks tired, tired, don't you think,' referring to Mrs. Morrison who had indeed looked exhausted in the evening; 'she looks tired', pause, 'you know I'm bullying her, *killing* her—that's what I've been doing for the past twenty-five years.' He dropped his eyes in fake contrition to the floor. Then a long reflective pause. 'But they tell me that a general kills a thousand men an hour in war—at least I'm only killing one woman!' And there he chuckled, his mind changed course and he was discussing Kruschev. 'What did I think of him? Ah—he's a great chap, no fool—a man after my heart. He understands the use of power. Yes indeed we discussed war and Kruschev said "well, it really begins on the baseball fields"—I do agree.' And then he sighed again and it was as if the wind itself had taken him by the hand and swept him into another memory sad/close to his wise and heavy heart.

It was then that our talk became something far beyond 'a famous grand old man' discoursing on his art and life and discoveries over eighty years. During the next four hours we touched on the primal principles and forces of man, and again and again Frost illumined that small wooden room with a thought of such penetration and positivity that it was easy to imagine that historic meeting, a week or so before, between Kruschev and himself— when these two important men had agreed in principle upon the necessary thought processes for permanent peace in the world. 'Yes, Kruschev is a great man, a man after

my heart—a man who uses power with courage and a boldness of purpose. You see, m'boy, that image of yours —the ward scales, well, it's good; but,' and then he chuckled, 'it doesn't say anything I haven't said before! But when you are my age you like confirmation of your work—you listen—we are talking about the same thing.' By then he was rumpling about in a pile of old books; 'Ah, here it is—you listen.' His voice melodied on like a high-land stream trickling over a pile of rusted hinges, reading from his own poem 'The Peaceful Shepherd'.

> If heaven were to do again
> And on the pasture bars,
> I leaned to line the figures in
> Between the dotted stars,
>
> I should be tempted to forget
> I fear, the Crown of Rule,
> The Scales of Trade, the Cross of Faith
> As hardly worth renewal.
>
> For these have governed in our lives,
> And see how men have warred.
> The Cross, the Crown, the Scales may all
> As well have been the Sword.

There, in that quiet midnight wooden room, I heard the prophet speak. The emotion which filled me bears no definition that I like to name. Frost paused, and the silence spoke for what was in both our hearts. The necessity for linking our paradoxical natures and the urgent need for *harnessing* the aggressive powers of man to a chivalrous rivalry, a lofty competition, full of magnanimous intentions and carried out in princely fashion. I quote the poet's interpretation of these particular shared thoughts. Frost again was speaking.

'This book of yours, "The Pendulum", the title is quite right, your theme of profound importance . . .' I quickly interposed, 'Excuse me, sir—obviously you realize how *much* it means to me, you thinking of this work in such positive terms—but the pain of attempting such a personal self-revealing is, I think, *too* much for me. I don't feel I can continue it without a mental breakdown. I've had too many.'

There was a long pause before Frost replied: 'There is nothing—or very little—that you can tell me about inner stress—but there is *much* that I should *like* to tell you'— and here his sad elusive psalmist countenance took on its profoundest depths. 'Poets such as you and I—and you are one at present in the making—have grave responsibilities which must be borne whatever the seeming cost may be.' He paused and with that lovely chuckle murmured four lines which I thought I knew by heart, but which until this moment I had only half construed.

The woods are lovely, dark and deep,
But I have promises to keep,
And miles to go before I sleep,
And miles to go before I sleep.

The great poet paused as only a great poet can. 'No artist worth his salt can squeeze out of that.'

By now he was holding the first few chapters of my attempted autobiography, and I was no longer timid or an outsider; I was a pupil keen to learn how I could best use my painful experiences to the fullest effect. In his inimitable voice Frost read me back the passage in which I had described the attempt for balance in our lives via the scales which I had seen during a long sojourn in hospital.

He paused, put down the typescript and stretched his hands towards the fire; 'In this you show yourself to be both perceptive and a poet. It is exactly in this kind of

attempted reconciliation between conflicting opposites
that unity is found. You know very well yourself from your
"troublesome past" that this is no easy matter to achieve—
but these experiences, trials and troubles are given to us
for exactly this—to be used and not to be ashamed of.'

I owe a profound debt to Robert Frost for that long
personal private and most generous tutorial; the stream
of wisdom flowed on long after he had put down the start
of my manuscript. Image after image cascaded forth, the
one tumbling upon the other, a waterfall of words and
wisdom—'man *must* contend, set forth, hold out—it's in
his nature to contend, then let him make *certain* of his
contention, hold it to the light, expose it to the skies—not
in shame and fear—but in honesty and delight. Delight in
a power that is *fully* understood—weighed like your
hospital scales, balanced through opposites that greet each
other for what they are,' Frost paused and looking at my
lap he saw a map of New England which rested there. I
had been trying, with not much success, to locate the
position of this Ripton chalet; immediately he seized upon
this fresh image and swept into the law of nations—'Yes
we *must* have *independent* nations INTERDEPENDENT upon
one another—complementary, vice versa—a see-saw—
mutuality—your ward scales . . .' and as he rustled on I
heard, clear as a bell, once again those profound words
from the 'Peaceful Shepherd', where signs and symbols
such as the Scales of Trade, the Crown of Rule, the Cross
of Faith spoke their duality and purpose—where a wrong
conception of these symbols would mean the sword rather
than security. In a flash I saw, as Frost spoke, the duality
and significance of the Cross—at once a symbol of suffer-
ing and angst, crossed and contradicted forms—and then
again as a sign of *pure* perfection, the marrying of the two
most positive movements, the vertical and the horizontal.
I was reminded of another great contemporary artist,

Piet Mondrian, the painter, and the profound words written by him in connection with the marrying of these two extremes—and the consequent moment of happiness, peace, 'perfection'.

We talked a lot more; we seemed to have touched upon nearly every subject of importance—somehow we did all this in four hours, whilst the fire which Frost had so proudly lit, burnt itself out and died away. The room was suddenly silent; Frost leant back in his huge and friendly armchair. The room was charged with magic—and peace was everywhere.

I was reminded of another idealistic and great thinker poet, Manley Hopkins and his words 'the world is charged with the grandeur of God—it will flame out, like shining from shook foil', came to mind, for all that Frost had spoken of had been positive and good and wholesome and honest and Godfearing and noble and magnaminous—and totally true.

I could continue with a host of other fragments of those illumined hours, and each would I think disclose another part of that warm wise poetic heart. But one moment, one answer to a question of mine, is so close to me in memory—and of such importance—that I should like to finish this talk by giving birth to it again. Like so much of our discussion, it was a moment given to the subject *nearest* to Frost's heart, his recent meeting with Kruschev—and their *agreement* that men must work in chivalrous rivalry and with magnaminity of purpose.

I had asked Frost if he was not frightened by the saying of a distinguished Roman Catholic Bishop from England —who had said: 'Communism and Democracy are like an ice cream and a furnace.' This statement had frightened me, from a distinguished person of high office and responsibility. He seemed to me to be suggesting that they must be kept apart. This to my mind expressed *fear* and fear

nearly always begets violence eventually. I was truly frightened by this statement. It was an entirely negative way of thinking. As a Roman Catholic I was rather ashamed of this negative statement—an image which could scarcely be interpreted but in one way.

Keep apart at all cost.

Frost smiled that deep wintry knowing smile, and as if looking back into the age of Adam and Eve, and linking Adam with Eve as the central father-figure—not patronizingly, but in true compassion and humility, he said, quoting what later I found to be his short poem 'Fire and Ice'—he said, the words tumbling rather more slowly and precisely than before—a sort of self reflective contemplative mumble, almost as if trying to prove something to himself—he said:

Some say the world will end in fire,
Some say in ice,
From what I've tasted of desire
I hold with those who favour fire.
But if it had to perish twice,
I think I know enough of hate,
To say that for destruction ice
Is also great
And would suffice.

the poem and the pause made a conclusive worldly-wise point for me.

Had it not been for that tutorial with Frost I should never have had the courage to continue with my autobiography. Nor would this book have ever been. During the next three years I struggled rewriting it five times and enduring over thirty rejection slips from publishers. I do not think I could have endured those difficulties without the knowledge that one of the great poets of our time had, a few years before, believed in what I was trying to say.

171

Chapter five

Old age, in profile; only half a chance to spy upon the brooding eye, the misted look, the sunken cheek.

It is difficult to draw the profile set back in space, to give through distance a sense of time and space. That head has taken up much space and time, through the years, to grant this age. Space takes a deal of room to make for itself a filling in. Time is not measured thus, though we are inclined to say we 'fill it in' like any other hole. How inaccurate are the many uses of our language But however much we may 'think' we 'fill it in', time has no valid space that we can measure. And whilst I drew, upon that flattened surface, 'age'—I felt I was construing time in her own timeless terms. It took a deal of time, and yet no space, to make that study of a profiled face in age. What thoughts were crammed, tight I must admit, into that lack of space!

I thought—one day I shall know that misty gaze when the eye fixes upon the present more for what it pretends is present and is really past; when the mind uses the present for the past, and the borrowed past is the only present.

Will I find such still acceptance in such a belated gift? Probing the sunken eye and tight lipped mouth, I thought of much time passed—that the present is the future in the making and that the future is never present except within the past. And so on—ad infinitum Old Age in Profile. The past made up, concocted, from these present lines of silhouette. A line drawn round an edge to lassoo what is not really there in space and which cannot catch the time! Such senselessness needs to be employed, with sense, when pursuing more than seventy years of feeling. More accurate, perhaps, to draw around an edge to what has no valid space within and is therefore more expressed in line —without. I thought it best that way, because a line takes time to make and that is clearly stated upon the faces of the aged. A line bitten in to depth, for a time engraved— by, with and from a space.

That cost and gave me time, that deep etched line which struck across his face.

About four years ago, I had drawn a child. Not just 'any' child. My son. Half a year passed three years old, the father to the man I drew—and I had wished my days to be 'bound each to each by natural piety'. It is strange and wonderful to draw—not in a mirror—but side by side and face to face what are part your eyes, your head, your shape of crown and hairs; to know and love so intimately the seriousness and smell, the laughter and the looking-ness. 'He looks like I look looking for myself,' I think; 'and I feel I look like he looks looking for himself'. We exchange looks like Lazarus must have swopped, on that great occasion, with Our Lord Lord *how* he looks and looks will always tell.

I was very conscious, for obvious reasons, of birth when I made that study of my son. Death, the day before, had haunted me through a sketch I had made of a train driver involved in a recent tragic disaster on the railways.

The driver's eyes seemed the buttons dangling from a tunic, his features wrought from twisted metal. His mouth was not so much across as up and down, a hump, a heap, a pile—two lines converging to form a memorial mount. I thought, his life was run on lines and yet it ran amok; how often he will be snatched from slumber by a pile of sleepers seized from sleep through screams and slaughter. I looked back, for assurance, to the drawing of my son.

Most of my work, both in painting and writing, has been concerned with the proximity of life and death—in some way or other—because of that terrifying illness which struck with so much violence, in Greece, when I was scarcely twenty. Death shook my hand, in early age, with his particular clammy form of greeting. I returned that shake, with quivering hand and sweaty palm, as best I could—and took it more as reckoning. From that experience I learnt that all adding up is a form of taking down. I think taking down is the safest way of adding up. And if this reckoning—adding up or taking down—is in any way correct, it makes the plus and minus the symbol of the same. I do not find it strange that the sign for wholeness is built from the form of nothingness.

Such thoughts were in my mind, when I made that drawing of the train crash driver; that if birth be right, then death must be distinctly left or absolutely wrong. For what, I thought, is left, surely must remain just as much as right. Without the left, there could be no definite right. Concerning that, I *knew* I was not wrong. Right is right and left, to most of us, is very slightly wrong. But remains are always left—that's a thought, I thought—because they do not stand the test of what is right. The memory for that driver will remain, in this disjointed world, as a testimony for what is partially left and was not wholly right. For right and wrong—thank God—are as much relations as life and death, in this uncertain world. And love

174

and hate have long with fire and ice been proximated.

I was drawing, one late summer evening, our daughter Annalisa. She sat at my desk with her back to me. We had agreed to draw each other and occasionally she turned and looked at me; but she concentrated mostly upon her piece of paper, and stared when stuck—much lost in thought—out through the window on to the thatched farm cottage which faces us. We call it 'Mrs Payne's', for no better reason than the fact that Mrs. Payne lives within it. I drew with the greatest concentration, determined to catch the concentrated action of our daughter in the act of drawing. It was a perfect summer evening. My daughter turned and asked if we could have some music on. I leant across my desk and switched on the wireless. I heard, to my delight, the opening bars of Beethoven's 'Pastoral'. I thought of all the things which I might link with such a melody as this; wet beer marks on a bar, ties loosened at the knot, the friendly kiss of coat lapels, short cropped grass, the shape within a turned up collar, a nurse's pure white cuffs, a pint (not a half) of beer, a far off motor mower purr, signposts near the sand, the look of my own handwriting, a bicycle leant lazy to a wall, the saffron scent of summer, a whole new rounded cheese, the moon, a pat of rounded butter, shadows upon a window sill, the smile of tiles drenched wet from rain, a large lazy field of clover—a pair of bath taps, rain dripping from a gutter, the cool breeze across spring daffodils, a pipe laid upon a desk near a tobacco tin . . .

The list would be much longer if my daughter had not turned to question me.

'Daddy, that's the *Pastoral*, isn't it? We had it at school last week.'

'Yes, darling, this is the really tender part.'

'It's all about the air and fields and trees and sky—isn't it, Daddy?'

'Yes,' I said, 'that's just what it's all about.' There was a pause. 'Have we had the thunder part yet?'

'No—that sterner part comes later.' I continued drawing.

Another, longer pause. 'And then after the thunder,' said my daughter, 'you can hear the sun come out.'

I thought, there's not much wrong with a composer who can make a child hear the sun come out after he's scored in music the temper of the thunder. I know that summer evening was for both of us complete.

'Daddy, I've finished my drawing.' Gently my daughter pushed back the large wooden chair upon which she had sat—and handed me her drawing. 'It's not very like you,' she said; 'you're difficult to draw.'

'Not as difficult as some,' I said. I looked at the drawing and saw some words pencilled neatly in beneath it. I put on my glasses and peered closer at them.

'Have I spelt Rosemary right?' my daughter asked.

'Yes,' I said, 'almost. You've just left out an "e" and "y".' I explained where they fitted.

She took the piece of paper from me and returned it in the briefest time. 'That's all then,' she said, 'ah, there's the thunder bit—the sun is nearly out.'

I looked back at the piece of paper and then I read:

<div align="center">

E

'LOVE FROM MRS. PAYNE LOVE FROM ROS/MARY LOVE

Y

FROM MUMMY LOVE FROM EVER/BODY.'

</div>

There are no lines, and even fewer drawings, which have so much linked the golden chain of my content. Do you wonder that I love the periphery of my daughter's grey school hat, even without her in it?